mysterious

TALES

of

COASTAL

North Carolina

Mysterious TALES of COASTAL North Carolina

Sherman Carmichael

illustrations by

Sarah Haynes

THE
History
PRESS

Published by The History Press
Charleston, SC
www.historypress.com

Illustrations by Sarah Haynes.

First published 2018

Manufactured in the United States

ISBN 9781625859624

Library of Congress Control Number: 2017963234

This book is dedicated to Beverly Carmichael, who spent many hours correcting my mistakes; Michael and Kelly Brosky, for their interview; Ric Carmichael; Tamara Carmichael; Blake Mahaffey; Sean Mahaffey; my attorney Greg Askins; Cindy James; and Lynette Goodwin.

Contents

CONTENTS

CONTENTS

I.

Disasters and Shipwrecks

JUST A THOUGHT

Great disasters have taken place throughout recorded history. Some disasters are caused by human intervention and some by human negligence. From the time of Noah and the biblical flood and likely long before, natural disasters have been happening and will continue until the end of time. Natural and man-made disasters are on the rise at an alarming rate. In fact, it's possible that a natural disaster will bring the end of time. Consider Revelations 6:12–13, "I looked when He opened the sixth seal and behold there was a great earthquake. And the stars of Heaven fell to the earth"; and 10:13, "In the same hour there was a great earthquake and a tenth of the city fell. In the earthquake 7,000 people were killed." Is the Maker trying to tell us something?

A *New York Times* article said that humanity has an extraordinary talent for causing catastrophes. We are even likely, as many have suggested over the past century, to be responsible for the coming apocalypse.

Natural disasters are sudden and extreme events caused by environmental factors, such as earthquakes, volcanic eruptions, tornadoes, hurricanes and floods.

Human-caused disasters include train wrecks, fires, plane crashes and explosions. Most man-made disasters are caused by human error. On April 15, 1912, the RMS *Titanic*, a British passenger liner, sank in the north Atlantic Ocean after colliding with an iceberg, resulting in the deaths of 1,500 passengers and crew. On February 1, 2003, the space shuttle *Columbia* broke apart while reentering the atmosphere over Texas, killing all seven crew members.

Webster's New World Dictionary defines *disaster* as "an event causing great harm or damage."

Can the increase in natural disasters be a warning of things to come? What comes next? How will we handle it?

Bachelor Creek Torpedo Explosion, 1864

O n May 27, 1864, at about 4:00 p.m. a train carrying four torpedoes pulled into the Bachelor Creek, North Carolina train station. The train left New Bern, North Carolina at 3:00 p.m. and arrived on time at Bachelor Creek. These four torpedoes were scheduled to complete the blockade of the Neuse River. The first three torpedoes were unloaded without incident. As the fourth was nearing the station platform, everything was looking good until a stick of wood hit the cap. Disaster followed.

The explosion of the fourth torpedo was so great that it caused the other three to simultaneously explode. The explosion of the four torpedoes was so fast that it sounded like one great explosion.

Many soldiers were standing around the train station waiting on news from Virginia. These soldiers, along with others at the station, were blown into eternity. Body parts were blown for a quarter of a mile around. Many could not be recognized.

The building suffered severe damage from the torpedoes' explosion. The signal tower and commissary building were built out of logs that were thrown as much as eight hundred feet from the explosion.

Forty men were killed in the explosion, and many others were seriously injured.

2

June 2008 Wildfire

Nature strikes back. On Sunday June 1, 2008, during a storm, a lightning strike ignited a fire in the Coastal Plain of North Carolina. The wildfire started on a wildlife refuge in rural eastern North Carolina and burned onto privately owned land, doubling in size. Smoke and ash from the fire reached as far as the Outer Banks and Virginia. Manteo, North Carolina, about forty-five miles east of the fire, and Chesapeake, Virginia, seventy-five miles north of the fire, had their air filled with ash and smoke. At the time, it was the largest active wildfire in the United States.

The wildfire burned about thirty thousand acres on the Pocosin Lakes National Wildlife Refuge and on private land in Hyde, Tyrell and Washington Counties. Wildlife management doesn't believe that it has caused any serious damage to the wildlife in the area.

The fire spread quickly because of the dry conditions and a lot of flammable peat soil. *National Geographic* news reported, "North Carolina's Coastal Plain Region has about five hundred square miles of peat that can be up to fifteen feet thick in some areas. Peat is partially decomposed plant matter formed in wetlands that can be harvested as fuel. Firefighters face an unusual danger because the fire can travel underground and suddenly blaze up behind them."

About 450 firefighters were on the ground battling the roaring blaze using bulldozers and other earth-moving equipment to build firebreaks. The North Carolina Forestry Service dropped water on the fire from helicopters.

Emergency workers evacuated a community around Lake Phelps, North Carolina, thirty-nine homeowners. Eighty homes had to be evacuated in Hyde and Washington Counties. Hyde, Tyrell and Washington Counties were put under a state of emergency.

The fire sent a great plume of smoke forty-five thousand feet into the atmosphere. There was such a great amount of heat produced by the fire that when it reached a certain height it created its own weather conditions and possibly could have created lightning. Unless there's a very large rainfall, like that accompanying a tropical storm or a hurricane, to put out a wildfire, it could last for months.

The only injuries related to the wildfire were bee stings and poison ivy reactions.

3

Steamer *Pulaski* Explosion, 1838

On Thursday June 14, 1838, the steam packet *Pulaski* left Charleston, South Carolina, headed for Baltimore, Maryland. The *Pulaski* was manned with 37 crew members and carrying 160 passengers, of which 50 were ladies. The *Pulaski* was under the command of Captain Dubois.

About thirty miles off the coast of North Carolina, traveling in moderate weather on a dark starry night, no one realized that disaster was just minutes away. About 11:00 p.m., the starboard boiler exploded. First Mate Hibberd was in charge of the boat at the time of the unexpected explosion. He had taken command at 10:00 p.m. After the explosion, the dazed Hibberd managed to pull himself together and make it to the site of the boiler explosion. The boat's midships was blown to pieces, and the *Pulaski* was taking on water each time it rolled in that direction. Hibberd began letting the passengers know that the boat was sinking. The yawls were lowered, but some sank because of long exposure to the sun. Forty-five minutes after the boiler explosion, the *Pulaski* went to the bottom. The passengers in the remaining lifeboats could see the hopeless people holding onto whatever was available and floating in all directions. The two yawls and fourteen people survived under the direction of First Mate Hibberd.

4

USS *Huron*

The USS *Huron* was built in 1875 in Chester, Pennsylvania. Its length was 175 feet, the beam was 32 feet, and it boasted a compound steam engine with five coal-burning boilers, a 12-foot propeller and three masts with sails.

Its armament consisted of one eleven-inch Dahlgren smoothbore cannon, two nine-inch Dahlgren smoothbore cannons, one sixty-pound Parrott rifle, one twelve-pound Dahlgren boat howitzer and one fifty-caliber Gatling gun.

USS *Huron* was a 120,000-ton Alert Class Screw Steam gunboat commissioned in November 1875 manned by 16 officers and 118 enlisted men.

During its brief career, from 1875 to 1877, the USS *Huron* visited ports in Mexico, Venezuela and Colombia; Key West, Florida; Mobile, Alabama; Charleston, South Carolina; Norfolk, Virginia; Boston, Massachusetts; New York; and Washington, D.C.

The USS *Huron* left Hampton Roads, Virginia, on Friday, November 23, 1877, headed for Havana, Cuba. On the first night at sea, it encountered a storm with strong winds blowing from the southeast. The storm winds, combined with a small error in the ship's compass, caused the ship to run aground off Nags Head, North Carolina, at about 1:30 a.m. on November 24, 1877. The USS *Huron* struck ground two miles north of lifesaving station no. 7, which was not manned.

Grounded, the USS *Huron* was about two hundred yards from the beach. Due to the heavy surf, strong currents and cold temperature, most of the

crew were stranded on the ship waiting for help. No help ever came. Many of the crew were washed overboard by high waves. Ninety-eight men lost their lives during the night. The USS *Huron* was under the command of George P. Ravan.

The wrecking steamer *Resolute*, the USS *Swatara* and the tug *Fortune* were sent to render assistance, but they were too late. Today, the USS *Huron* site is located about 250 yards from the beach. Buoys mark the bow and stern of the wreck during the summer months.

In the 1870s. the ship's cannons and much of the machinery were salvaged. Today, collecting artifacts from the wreck is strictly prohibited. The shipwrecks in North Carolina waters are protected by state and federal law.

The USS *Huron* is listed in the National Register of Historic Places, and in 1991, the secretary of the North Carolina Department of Cultural Resources designated the site as North Carolina's first Historical Shipwreck Preserve.

The *Huron* marker reads, "The wreck of the Huron near this spot." On November 24, 1877, the USS *Huron* ran ashore, and ninety-eight lives were lost.

5

City of Atlanta

The *City of Atlanta* was completed in April 1904 by the Delaware River Iron Shipbuilding and Engine Works of Chester, Pennsylvania. The owner was the Ocean SS Company out of Savannah, Georgia. It was a 5,269-ton steam merchant ship with a planned route from New York to Savannah, Georgia.

Over the years, it would be plagued with three misfortunes. It seemed the *City of Atlanta* was going to be followed by disasters and have an accident every five years. On October 29, 1920, it badly damaged the bow in a collision with the concrete ship *Cape Fear*. The *Cape Fear* sank in three minutes off Narragansett Bay. On February 10, 1925, the *City of Atlanta* was involved in another collision with the barge *Juniper*. The barge also sank, off York Spit, Baltimore. On May 14, 1930, *Atlanta* collided with another vessel, this time with the schooner *Azua*, which sank southeast of Barnegat, New Jersey.

In January 1942, the *City of Atlanta* left New York for Savannah, Georgia, carrying three thousand tons of food and a few passengers. The captain was staying as close to the coastline as he could and keeping the navigational lights dim, trying to avoid U-boats. Despite his efforts, there was a U-boat patrolling the waters of the North Carolina coast. The U-boat spotted the *City of Atlanta* hugging the coast and started tracking the steamship. The U-boat followed the *City of Atlanta* for almost three hours before coming within 250 meters of the ship.

At 9:09 a.m. on January 19, 1942, the *City of Atlanta* was hit by a torpedo from the U-boat, *U-123*, eight to ten miles off the coast. The torpedo struck the waterline with a massive explosion, and the ship sank in about ten minutes—before any of the lifeboats could be lowered. All the people on the *City of Atlanta* perished, except for one officer and two men who survived by clinging to the wreckage. They were picked up by the *Seatrain, Texas*, after about six hours.

The *City of Atlanta* is under about ninety feet of water east of Buxton, North Carolina. Today, the site mostly consists of a large debris field.

6
USS *Tarpon*

The builder of the USS *Tarpon* was the Electric Boat Company of Groton, Connecticut. It was laid down on December 22, 1933, and launched September 4, 1935. The *Tarpon* was commissioned March 12, 1936, and decommissioned on November 15, 1945. A 287-foot-long diesel electric submarine, *Tarpon* traveled at a speed of 19.5 knots surface and 8.25 knots submerged. It carried five officers, commanded by Lieutenant Leo L. Pace, and forty-nine enlisted men.

The *Tarpon* was armed with six twenty-one-inch torpedo tubes—four forward, two aft—sixteen torpedoes, one four-inch fifty-caliber deck gun and two machine guns. The submarine was sponsored by Eleanor Katherine Roosevelt, the daughter of Assistant Secretary of the Navy Henry L. Roosevelt.

The USS *Tarpon* operated out of San Diego, California, and Pearl Harbor, Hawaii, with the submarine division. After several years, it was assigned to SubDiv 14. In October 1939, SubDiv 14 was transferred to the Philippines. In 1941, SubDiv 15 and 16 were transferred to Manila; the *Tarpon* was part of this group. This transfer increased the Asiatic fleet to twenty-nine submarines.

Two days after the Japanese attack on Pearl Harbor, the USS *Tarpon*, under Lieutenant Commander Lewis Wallace, was assigned to southeastern Luzon. It ended its first patrol on January 11, 1942, without firing a torpedo.

On January 25, 1942, *Tarpon* began its second patrol, to the Moluccas. On February 1, 1942, it fired four torpedoes at a freighter, with one hit. *Tarpon* fired two more, and both hit the target. On February 11, 1942, the *Tarpon* was spotted by the enemy. Diving deep but not fast enough to avoid four depth charges, its bow planes, rudder angle indicator and port annunciator were knocked out.

The night of February 23–24, *Tarpon* ran aground while navigating Boling Straight, west of the Flores Islands. Jettisoning everything that wasn't attached did not lighten the sub enough to let it float off. When high tide came in, with three engines in reverse, it slid off the bottom. *Tarpon* returned to Fremantle, Australia, on March 5.

The submarine's third patrol started on March 28 and ended at Pearl Harbor on May 17, 1942. Its next mission was north of Oahu for defense during the Battle of Midway, which lasted from May 30 to June 9, 1942. Next, *Tarpon* was sent to San Francisco, California, for an overhaul, which was completed on September 30, 1942.

The *Tarpon* was assigned to Japanese home waters south of Honshu on January 10, 1943.

On February 1, 1943, at 21:30 hours, south of Mikurashima, the *Tarpon* fired four torpedoes at a ship; firing two more broke the *Fushimi Maru* in two. On February 8, 1942, the *Tarpon* fired torpedoes at the ship *Tatsuta Maru*, which was destroyed and sank. The *Tarpon* returned to Midway on February 25, 1943. On August 21, 1943, the *Tarpon* fired on two cargo ships, damaging both. On August 28, *Tarpon* fired on another freighter, damaging it. On September 4, 1943, it sank a patrol ship, and on September 8, 1943, the successful sub returned to Midway.

On October 16, 1943, while patrolling the approaches to Yokohama, *Tarpon* spotted what was thought to be a large auxiliary ship. At 1:56 the next morning, it fired four torpedoes, which stopped the ship, but the quarry quickly got underway again. The *Tarpon* submerged under the ship then attacked it from the other side with three more torpedoes, scoring another hit. After another hit, the ship exploded and sank. On November 3, 1942, the *Tarpon* returned to Pearl Harbor.

The USS *Tarpon*'s final war patrol was from August 31 to October 14, 1944. The crew then returned to Pearl Harbor. Leaving Pearl Harbor on Christmas Eve, 1944, *Tarpon* arrived at New London, Connecticut, on January 17, 1945. The submarine was decommissioned in Boston on November 15, 1945, and scheduled for Naval Reserve training.

On September 5, 1956, the *Tarpon* was taken out of service and stricken from the navy list. The *Tarpon* received seven battle stars for it part in World War II.

As the *Tarpon* was being towed, it foundered in deep water south of Cape Hatteras, North Carolina, on August 26, 1957. The World War II sub lies on the bottom at a depth of 130 to 140 feet.

7
SS *Liberator*

The SS *Liberator* was built in San Francisco by the Bethlehem Fairfield Ship Building Company. It was originally commissioned as a cargo ship for the Lykes Brothers Steamship Company out of Tampa, Florida, and the port of registry was Galveston, Texas. Launched on March 24, 1918, the *Liberator* was 410 feet long and 56 feet wide, with a gross tonnage of 7,720.

During World War I, the *Liberator* was modified for war and designated the USS *Liberator*. The USS *Liberator* was a troop transport carrying troops from Saint-Nazaire, France, back to the United States. It was assigned to the U.S. Navy on July 2, 1918.

The USS *Liberator* headed for New York, arriving there on August 7, 1918. The ship was loaded and joined a convoy on August 13, headed for France. The journey took fifteen days. *Liberator* continued to transport troops until the fighting stopped in November 1918. It made five trips to and from Europe bringing soldiers home from France.

The USS *Liberator* was decommissioned in October 1919 in Hoboken, New Jersey, and sat in government surplus inventory until 1933. It was sold to the Lykes Brothers Steamship Company of New Orleans, Louisiana, and converted into a cargo vessel.

The SS *Liberator* operated out of Galveston, Texas, carrying bulk cargo, and was a commercial vessel during World War II. It was, however, modified with deck guns for protection from U-boats.

At dawn on March 19, 1942, the SS *Liberator* passed Cape Lookout, North Carolina, and the crew spotted a large tanker burning. The captain and crew went to full alert. They intercepted radio traffic saying that U-boats were responsible for the attack on the tanker and immediately went to full speed to get out of the area.

A U.S. Navy destroyer, the *Dickerson*, was in the area to assist the tanker. The crew of the *Liberator*—thinking the *Dickerson* was a U-boat—opened fire, killing several sailors. The *Dickerson* headed back to Norfolk, Virginia.

By 10:15 a.m., the SS *Liberator* was passing Diamond Shoals buoy. It was joined by the freighter *Chester Sun* and the tanker SS *Esso Baltimore*.

Suddenly and without warning, a torpedo struck the SS *Liberator* portside at the engine room, killing five men. The ship came to a stop. Captain Albin Johnson ordered the crew to the deck and gave the order to abandon ship. Thirty-one crewmen evacuated the craft in two lifeboats. At 10:40 a.m., the SS *Liberator* sank.

The crew was rescued at about 11:25 a.m. when the navy tugboat USS *Umpqua* picked them up. The tug dropped them off at Morehead City the next day.

The German U-boat *U-332* was responsible for the loss of the SS *Liberator*.

The ship sits on the bottom at a depth of 120 feet off Diamond Shoals, North Carolina. It is broken into a few pieces, with the bow section facing aft.

The Lykes Brothers owned steamship company outposts in New Orleans, Louisiana; Galveston, Texas; and Tampa, Florida. The SS *Liberator* operated out of Galveston and was owned by the Lykes Brothers when it sank.

8

The *Empire Gem*

The *Empire Gem* was a 1,139-ton motor tanker completed in 1941 by Harland and Wolff Ltd., Goven Glasgow, Scotland, for the Ministry of War Transport (MoWT). The ship's owner was a British Tanker Company Ltd. of London, England. *Empire Gem*'s home port was Glasgow, Scotland, and it had a route from Port Arthur, Texas, to Halifax, United Kingdom. The tanker was armed with a stern-mounted four-inch gun, several machine guns and a twelve-pound antiaircraft gun.

At 2:40 a.m. on January 24, 1942, the *Empire Gem* was hit midships and aft by two torpedoes from *U-66* fifteen miles southwest of Diamond Shoals buoy off Cape Hatteras, North Carolina. The tanker, which had been traveling in a zigzag course to evade U-boats, caught fire and became a raging inferno.

By the next morning, the stern had fallen away and sunk. The blazing bow section flipped over and sank the next day. Two of the fifty-seven crew survived. The wreck sits 120 to 150 feet below the surface.

Steamer *Metropolis* Wreck, 1878

T wo hundred people lost their lives when the steamer *Metropolis* wrecked off Currituck Beach off the North Carolina coast. Fifty people were washed ashore and survived. The *Metropolis* of New York was bound from Philadelphia, Pennsylvania, to Para, South America, with stores and laborers on board.

On January 31, 1878, at about 6:30 p.m., a hurricane-force gale from the southeast buffeted the steamer, and the *Metropolis* grounded on the outer bar of Currituck Beach. It was about ten miles north of the Kitty Hawk, North Carolina signal station. Once the *Metropolis* hit the bar, it bilged and floated broadside to the sea. Several of the lifeboats were washed off the ship and out to sea.

The sea was making complete breaches over the *Metropolis*, washing everything, including passengers, into the raging water below. Because of the noise from the howling wind and the roaring of the raging water, the passengers could not hear the orders from the officers.

Hurricane Barbara, 1953

On August 11, 1953, a hurricane started forming from a tropical wave in the southern Bahamas. It was named Barbara, as it was the second hurricane of the season. Hurricane Barbara began to slowly move north and became a fully fledged hurricane on August 12. In the early morning of August 13, Hurricane Barbara became a Category 2 hurricane as it approached eastern North Carolina. Just south of Cape Hatteras, Barbara reached its peak, with winds clocking in at 110 miles per hour, but the punishing gale was sustained for only one minute.

The hurricane moved over North Carolina's Outer Banks overnight and crossed the shore between Morehead City and Ocracoke at about 6:00 a.m. As Barbara moved north and curved east back toward the sea, it began to weaken. The hurricane moved along the southeast of the New England region and dissipated on August 16. Most of the destruction was limited to crops in North Carolina and Virginia, an estimated $1.3 million in damages.

The coast of North Carolina suffered power and communications outages; roofs and signs were blown away. High tides and heavy rain flooded streets and highways with up to two feet of water. Cape Hatteras and Cherry Point were hit with ninety-mile-per-hour wind. Morehead City and Atlantic Beach were hit with sheets of rain and seventy-mile-per-hour wind. Eight to ten stores in the New Bern business district flooded.

There were two fires during the hurricane. The switchboard at the Gaston Hotel caught fire but was quickly extinguished, and a house burned to the ground because the fire department couldn't get to it.

The town of Avon on Hatteras Island was isolated for a while because of high water on the highway. Highway 17 between Elizabeth City and Hertford was closed due to high water.

Vacationers and local residents sought shelter in schools, hotel lobbies and other buildings. About fifty thousand people were evacuated or moved to shelters. One death and five injuries were related to Hurricane Barbara.

The Great Hurricane of 1899

The Great Hurricane of August 1899 was one of the strongest hurricanes to move through the Atlantic Ocean in the nineteenth century.

The hurricane crossed Puerto Rico on August 8 without any warning, killing hundreds of people. The total was unknown. The next day, it moved over the Dominican Republic. Its northwest movement brought it near Florida's oceanfront resorts on August 13. The hurricane moved past the Fort Lauderdale region on the morning of August 16, and it slowed down and changed directions, heading to the northeast. As it moved toward Cape Lookout, it increased in strength.

On the morning of August 17, the hurricane swept over the lower banks near Diamond City. In Carteret County, the island communities of Shackleford Banks, Diamond City and Portsmouth were hit hard. After being affected by several hurricanes prior to the hurricane of 1899, the communities had begun to see a steady decline in population.

The hurricane of 1899 dealt the final blow for Diamond City and Shackleford Banks. Few homes escaped the rushing tides. The hurricane approached from the south, pushing rising water toward the lower banks. As the hurricane continued to move southwest, it again pushed water toward the lower banks. The water caused untold destruction: most of the livestock drowned, fishing equipment was destroyed and homes were left in total ruin. After the storm, caskets and bones were unearthed by the hurricane.

Following the hurricane of 1899, the people of Diamond City and Shackleford Banks gathered what little was left of their belongings and left in search of a new place to live. Many moved to the mainland. A few managed to salvage their homes by floating them across the water on barges and putting them on new foundations. There was no report on how successful that was.

August was mullet season, and a group of twenty regular fishermen headed to Swan Island. They had established their camp on the island. When the first signs of the hurricane appeared on August 17, the tide was getting higher than usual and heavy rains pounded the island. They packed their supplies aboard their skiffs and tied them together.

The fishermen work to keep their skiffs afloat in one-hundred-mile-per-hour winds and the rising tide. In the early hours, the wind died down and the tide was unusually low. The fishermen were trying to decide about heading across the water to the mainland. They decided to go for it—a major mistake. The calm that gave them a false sense of hope was the eye of the storm. As it was passing over them, the weather would not stay calm long. Within minutes, the wind was at full force. The small skiffs now in open water didn't stand a chance. They capsized. Six of the twenty fishermen survived.

Ocracoke Island was a complete wreck according to the *Washington Gazette*. The hurricane had swept the entire coast of North Carolina, leaving ruins and disaster in its path. Thirty-three homes and two churches were destroyed. Every house on the island was damaged. The survivors of Ocracoke Island endured much suffering.

Hatteras Island was devastated by the hurricane. The winds clocked at sustained speeds of over 100 miles per hour. Gusts measured between 120 to 140 miles per hour. The land was covered with three to ten feet of water. The tide swept over the island, carrying everything that it could possibly carry with it. The frightened people were huddled sometimes forty to fifty people in a house. Many were clustered upstairs, as water stood several feet deep in the lower story.

The hurricane hit the northern Outer Banks with high winds and flooding. Nags Head was hit with the rising water of the Atlantic Ocean and the wind-driven waters of Albemarle Sound flooding the entire area.

The hurricane of 1899 scuttled or sank numerous ships from Wilmington to the Virginia line. Here are the names of a few that were wrecked due to the hurricane:

Aaron Reppard
Albert Scultz
Charles M. Patterson
Diamond Shoals' Light Ship
Edward A. Smith
Florence Randall
Fred Walter
Henry B. Cleaves
John C. Haynes
Lydia Willis
M.B. Miller
Minni Bergan
Pricilla
Robert Dasey

Thirty-five sailors were saved as their ships broke apart; thirty sailors were lost according to the newspaper accounts. The real number could have been much higher.

North Carolina Waterspouts, 1911

On July 27, 1911, at 3:30 p.m., several waterspouts entertained the guests at the Atlantic Hotel and the soldiers at Camp Glenn, North Carolina. The first waterspout began as a nearly invisible ghostly spiral of wind and water. The waterspout rose up from the ocean about four miles out until the top was lost in the clouds. This was a fair-weather waterspout, which forms along a line of developing cumulus clouds. This type of waterspout is not usually associated with thunderstorms.

The waterspout was partially straight, then started to bend and twisted until it absorbed a smaller developing one. The bottom of the waterspout was estimated to be about eighty to one hundred feet in diameter. When the waterspout dissipated, a shower followed, and in about an hour, the sun was shining. There was no damage from the waterspout.

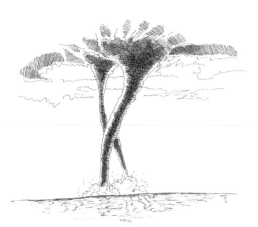

A waterspout is an intense columnar vortex that occurs over a body of water. Some refer to them as tornados over water. They can cause significant damage to a boat or if they make landfall.

Back in my younger days, I had the pleasure of seeing a waterspout off the coast of South Carolina. I was picnicking at the Myrtle Beach State Park at the time of the sighting.

Camp Lejeune Helicopter Crash, 1985

The third worst helicopter crash in U.S. Marine Corps history happened October 16, 1985, at 6:07 a.m. Three crew members and twelve marines were killed in the crash. There were four survivors, rescued by military divers. The four survivors were listed in good condition aboard the USS *Guadalcanal*.

A marine CH-46 Sea Knight helicopter was participating in an assault exercise. The CH-46 helicopter crashed shortly after taking off from the USS *Guadalcanal* (an assault helicopter ship used for beach assaults) into the Onslow Bay about 1,500 yards off Camp Lejeune Marine Base. The helicopter was participating in a military exercise with the Twenty-Sixth Marine Amphibious Unit.

A search-and-rescue helicopter with military divers on board was hovering above the ship and able to reach the crashed helicopter immediately. The bodies were removed from the helicopter Tuesday afternoon and taken to the naval hospital at Camp Lejeune.

Salvage operations for the helicopter were not too difficult, as the helicopter was 1,500 yards off the coast and in about 50 feet of water. The helicopter was removed from the ocean floor and taken to the New River Air Station or the Cherry Point Marine Air Station for examination by the Marine Aircraft Mishap Board.

Dixie Arrow

The 8,046-ton Americans steam tanker *Dixie Arrow* was completed in 1921 by the New York Ship Building Corporation in Camden, New Jersey. The owner of the tanker was Socony Vacuum Oil Company Inc. of New York, and it port of registry was New York, New York. The *Dixie Arrow* was 468 feet, 3 inches long and 62 feet, 7 inches wide. It could carry a cargo of 86,236 barrels of crude oil and had a crew of thirty-three.

Between 1923 and 1931, *Dixie Arrow* served the largest oil-producing and consuming centers of the United States. The *Dixie Arrow*'s coastal route did not change with the United States entering into World War II, and the ship continued to transport oil between Texas and the northern Atlantic states.

At 2:59 p.m. on March 26, 1942, the unescorted and unarmed *Dixie Arrow* proceeding in a zigzag pattern at eleven knots was hit on the starboard side by two torpedoes from *U-71* twelve miles off the Diamond Shoals buoy. In less than one minute, the *Dixie Arrow* was fatally damaged. The first hit destroyed the deckhouse, killing all deck officers, the radio operator and several others. The second torpedo hit the mast and the smokestack and broke the ship in two. Flames engulfed the *Dixie Arrow*. The engines were stopped. Eight men on the forecastle jumped into the water. Helmsman Oscar G. Chappell remained at his post and died when the flames blew back toward the bridge. Two hours later, the *Dixie Arrow* sank, a casualty of World War II's Battle of the Atlantic. Twenty-two of the thirty-three crewmen survived.

The remains of the *Dixie Arrow* rest in ninety feet of water fifteen miles south of the Hatteras Inlet. There is no remaining oil on the site.

Mystery Shipwreck Found
off North Carolina Coast

*A*scientist was searching for a missing mooring left behind in 2012 while on a research trip when the sonar scanning system detected a shadowy shape on the ocean floor. On July 12, 2012, an unmanned submersible called *Alvin* was used to locate the source of the shadowy shape. To the scientists' surprise, they had discovered a shipwreck. The remains of the shipwreck were more than a mile below the surface of the ocean about one hundred miles of the coast of North Carolina.

Archaeologists think the wreck may be a trade ship from the late eighteenth or early nineteenth centuries. Among the artifacts spotted were a metal compass, an iron chain, ship timbers, red bricks, glass bottles and a navigational tool. The team left everything in place except for a glass bottle brought to the surface for archaeologists to date.

A deep-sea research team that included scientists from Duke University and North Carolina State University found the ship by accident. Cindy Van Dover, director of the Duke University Marine Laboratory; Dave Eggleston, director of the Center for Marine Sciences and Technology at North Carolina State University; James Delgado, director of Maritime Heritage at the National Ocean and Atmospheric Administration (NOAA); and scientists from the University of Oregon made up the team.

The group was aboard the *Atlantis* research ship from the Woods Hole Oceanographic Institution in Woods Hole, Massachusetts. Bruce Terrell, chief archaeologist at NOAA's Maritime Heritage program, said NOAA will try to identify and date the artifacts and ship as soon as it can secure funding.

Oregon Inlet

*A*ccording to legend, in September 1846 a trading ship called the *Oregon* was returning to Edenton, North Carolina, from Bermuda. The journey was smooth until the winds picked up and the sky turned gray. The sailors aboard the *Oregon* knew what was in store—a hurricane. They knew their ship would be in danger if it was caught in the storm. It wasn't long before the ship found itself in the middle of the hurricane. The crew was desperately trying to keep the ship afloat when all of a sudden a tremendous wave lifted the ship and placed it on a shallow sandbar in the Pamlico Sound. The ship rode out the rest of the hurricane safely on the sandbar.

The following morning, the crew discovered the hurricane had done more than save the ship. As the sun rose, the crew of the *Oregon* found a huge cut in the island to the east of the Pamlico Sound. It took several days for the ocean to subside, and they floated free. The waves from the hurricane had washed out a new passage, and the *Oregon* was the first ship to travel through it.

The Oregon Inlet is the only inlet between Virginia and Hatteras. It is considered a vital passage for commercial and recreational boaters. Coastal scientists and mariners regard Oregon Inlet as one of the most dynamic inlets on the East Coast.

Mysterious Boat Washes Ashore on Outer Banks

On Tuesday afternoon, September 27, 2016, an abandoned boat washed ashore in Avon, North Carolina. The makeshift boat was an engineering marvel. It was made from metal pipes, angle iron, wood and pieces of rigid form. The boat had some supplies still in it. There was bottled water with labels from Cuba, tins of sardines and fuel. The engine still cranked.

The boat may have been carrying Cuban refugees. The fate of the passengers is not known. The vessel, which was first spotted floating in the Gulf Stream, had not been marked by the Coast Guard to signify the people on board had been rescued.

II.

Ghosts and Haunted Places

JUST A THOUGHT

As we continue to travel through the paranormal world we encounter strange happenings, things that just seem to defy explanation. In putting together the paranormal puzzle, we see that there are a lot of pieces still missing. Sometimes life is stranger than fiction. Sometimes we experience something that challenges our accepted view of reality or history, something that defies a rational or scientific explanation. Could it be that what we think is a paranormal experience is nothing more than an optical illusion? What if people who see ghosts are actually viewing that person in another time and space?

Let's forget the preconceived notion of chain-rattling ghosts lurking in the shadows of the proverbial dark, cold, windswept, stormy night. That's for Halloween and television. Nothing can blow a simple event out of proportion as much as Hollywood.

Does the truth lie in regions far removed and in much darker places than our human minds can understand?

Tales of the wandering spirits of the dearly departed can be found in the folklore of every culture since the beginning of recorded history. Stories of ghosts have captivated the imagination and frightened humans of all ages. Will the mystery of the afterlife ever be solved?

WHAT ARE GHOSTS?

From as far back as we can go, people have reported seeing ghosts, spirits, specters or whatever handle you want to put on them. Of course, the age-old question of what they are is still unanswered.

A lot more people believe in ghosts than will admit it. They are afraid people will look at them like they've just escaped from the loony bin. Then you have those that have seen something but they are not sure what it is. You have those who see a ghost in every building and around every corner like some of those wannabe spook seekers. While it is true that there are a lot of strange things going on that can't be explained, many of them are not ghosts.

Many believe that ghosts are the disembodied spirits of humans or animals that have not yet made it to their reward. Another theory is that ghosts are an unintelligent energy imprint that somehow remains in our world. Could it simply be the power of suggestion?

Even great scientists through the ages have been unable to give us an answer to what a ghost really is. They do maintain that ghosts don't exist. There is no conclusive evidence that ghosts do exist, but then there's no evidence that ghosts don't exist. There is no viable explanation as to what a ghost is.

Are ghosts the souls of the dearly departed that are trapped between worlds (our present world and the world of the hereafter), unable to move on? Could the spirit still exist on in this world and only appear at certain times, giving the living a glimpse of what they think is a ghost? Could it simply be the power of suggestion? Another theory is that we are seeing a rare glimpse of a past event that replays itself in our world at certain times.

Another question to ponder: if what we are seeing is the spirit of a dead person, then what are ghost objects? There have been many reports of ghost planes, ghost ships, ghost cars and a few reports of ghost buildings.

GHOST SOUNDS

Sounds don't have a soul or spirit and have never been a life form. What are the sounds we hear from the distant past? Are they ghosts' voices or disembodied voices presumed to be those of people who have died. How about on ancient battlefields? Many have reported hearing the sound of rifle or cannon fire. Others have reported hearing the sound of trains where there is no longer a track.

At times, ghosts are very clear and fully clothed. Other times, they are more of a mist or shadow. Some people believe there's a glitch in time

where past events continue to happen in the same location. If there is a rip in the fabric of time, then maybe it's not opening completely when we see mist or shadows.

INTERACTIVE GHOSTS

What are these unseen forces that interact with people or move objects? My book *Eerie South Carolina* contains two stories that I was researching when I saw objects move without any help from anyone. Aunt Sissy had parts of a candelabra moving with no one close to it. Barbara Bush's ghost Morganna opened a door with no one trying to enter. Are these ghosts just letting us know that they're here? Are they trying to tell us something we don't understand or are they just being pests?

Are these lost souls in need of our help, and can we help them?

Let's take this a step farther and look at ghosts, spirits or souls. Can they coexist with us in our world?

There are many more mysteries here than just ghosts. I am not trying to prove or disprove anything, just presenting the facts (if you accept these as fact) as I have gathered them. Now let's take a look at some.

There are too many interesting things to explore about the past, so much exciting and fascinating history and mysteries of the ancient world to limit ourselves to the history books written by people who include only what they want us to know.

Maco Light

Out of the fog-shrouded past comes another ghost light, the Maco Light, also known as the ghost at Maco Station. The Maco Light is one of North Carolina's most well known and enduring supernatural phenomena. With all ghost stories that endure the test of time and thousands of storytellers, the true facts sometimes get blurred.

One source says the original name of the station was Farmer's Turnout, later changed to Maco Station. There never was much to Maco, and there is even less now. There are a couple of rural roads and one country store near the intersection of U.S. 74/76 and North Carolina 87 in Brunswick County.

In 1867, fourteen miles west of Wilmington, North Carolina, near the small station of Maco, a train wreck occurred that went down in history. Brakeman Joe Baldwin was traveling in the last car on an Atlantic Coast Line train on the rail line that served Wilmington, North Carolina; Florence, South Carolina; and Augusta, Georgia. For reasons still unknown, Baldwin's car came uncoupled from the rest of the train. The caboose came to a stop on the trestle over marshy swampland.

Joe Baldwin was the only fatality in the accident. Baldwin knew that a passenger train was close behind the detached caboose and that the passenger train would collide with it unless he did something. Baldwin grabbed his lantern and rushed to the back of the caboose, swinging the light in an attempt to get the engineer's attention, but to no avail. The collision between Baldwin's car and the passenger train was so severe that Baldwin's head was severed. The impact threw Baldwin's lantern high into the air and into

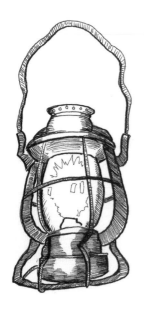

the surrounding swamp. It landed upright, flickering, but never went out. Baldwin was crushed in the impact. His mangled body was eventually removed from the wreckage, but his head was never found. He was laid to rest without his head. Soon after Baldwin's funeral, the mysterious light appeared along the tracks near Maco.

On misty nights Joe Baldwin's headless ghost appears at Maco with his burning lantern. It all starts out as an indistinct flicker of light, then the glow slowly moves forward, growing brighter and brighter as it nears the railroad trestle. Just before it reaches the trestle, the light bursts in a brilliant display then dims as it moves away.

Shortly after the train accident, other trains traveling the same tracks began reporting a strange light that would appear on the tracks until the train was almost to it before disappearing. Trains began stopping for the light with such frequency that the railroad started using two lights near the Maco Station, one red and one green. This kept the engineers from being confused by the ghost light.

In 1889, President Grover Cleveland, while on a political campaign trip, was on the train while it was taking on wood and water at the Maco Station, and he noticed the two lights and asked about them. He was told the story about Joe Baldwin's ghost light. President Cleveland took the story back with him to Washington, D.C., bringing national attention to the ghost light. One source on the Internet says that President Cleveland saw the light himself.

Shortly after the president's visit, an investigator from Washington, D.C., came and saw the light. He ruled in favor of swamp gas.

Automobile lights have been theorized as the answer to the Maco Light, but the light predated the automobile. An experiment that stopped all traffic in the area had negative results—the light still appeared. From 1873 until after the 1886 earthquake, railroad workers reported seeing a pair of lights that would appear together.

The light has been studied by paranormal investigators, the Smithsonian Museum, soldiers from Fort Bragg and a research team commissioned by President Grover Cleveland. It was investigated by two electronics engineers

from radio station WWOK, one from WKIX and, in July 1962, an engineer from Bell Laboratories.

Several publications have written about the Maco Light. The *Atlantic Coastline News* (1932), the *Railroad Telegrapher* (1946) and *Life* magazine (1957) all did stories on the Maco Light.

Records of train wrecks in that area show no records of a Joe Baldwin being killed in a train accident. Accounts of a train accident ten years earlier list a Charles Baldwin being killed on impact, but he was not decapitated. Conductor Charles Baldwin was killed in an accident in January 1856.

After the tracks were removed in 1977, the ghost light disappeared for good. The legend suggests that the reason the light disappeared was that Baldwin's purpose was completed. He warned approaching trains of his stalled car. Since the tracks have been removed, there are no trains and no reason for Baldwin to remain. Maybe now Joe Baldwin is at rest. Old Joe Baldwin's lantern will cast its light no more.

Maco has no museum, no historical marker and no visible remembrance of the ghostly light except a street named Joe Baldwin Drive. The Maco Light was seen for over one hundred years.

Maco stands on top of a geological fault line. Speculation is the source of the light was static electricity powered by the pressure of the fault building up.

Ghost Ships

Ghost ships have sparked fascination and fear in mariners and others since the beginning of maritime travel. The ghost ships can be anything from ships that seem to appear out of nowhere to an eerie apparition on the horizon. They can remain for seconds to any length of time, then disappear as quickly as they appeared. Then there's the ship that's just drifting along, seemingly abandoned, for no reason. Some crews have abandoned ship mid-meal without explanation, never to be seen again. No one ever seems to find a reasonable explanation.

Ghost ships that creep on the fog-shrouded ocean will forever fascinate us and strike fear into our hearts. These phantom ships that no longer exist or mysteriously abandoned ships have haunted the oceans and sailed into our nightmares for centuries.

Ghost ships continue to invite speculation and mystery in the nautical world.

The Flaming Ship of Ocracoke

\mathcal{U}nusual things happen off the shore of Ocracoke Inlet. History surrounded by legend and woven into the fabric of time creates some of the most unusual stories. Ocracoke Island is full of myths and legends and some true stories, like that of the Graveyard of the Atlantic.

In the late seventeenth and early eighteenth centuries, religious wars ravaged Europe, vicious conflicts between the Catholic and Protestant factions. Thousands of Palatines, as they were called, immigrated to England for refuge from the wars. But British citizens began to complain. Swiss baron Christopher von Graffenried, armed with an idea to make his own fortune and rid England of some of the Palatines, approached the queen. He proposed to take hundreds of the Palatines to a settlement in the province of Carolina. The migration had many problems, but they finally settled on a large portion of land in what is now eastern North Carolina.

Another ship loaded with Palatines, who were much wealthier than the first ship's passengers, set sail for Carolina. Ocracoke Inlet was the principal point of entry for the ships. The large ships could anchor just outside of the inlet and send the passengers in by smaller boats.

The ship arrived just before dawn and anchored in the calm waters just off Ocracoke Inlet. The captain of the ship was an unscrupulous man with an equally unprincipled crew. That night, the captain and crew put their plan into action. The passengers were told that they would unload in the morning and should go below and get some sleep. As the passengers slept below deck, the crew murdered every man, woman and child. They collected

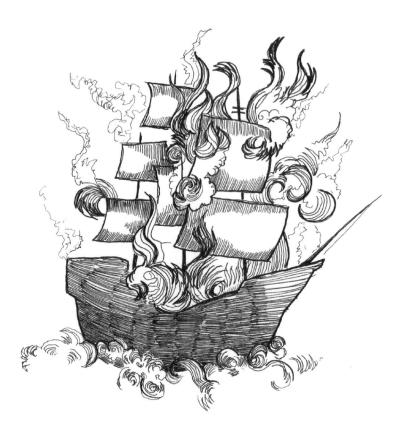

their treasure and loaded it into the ship's longboat. Once they were ready for their escape, they set the ship on fire to destroy any evidence of the brutal murders. The captain and crew watched from a distance as the fire quickly spread, but the ship didn't sink as planned. The night was the first full moon of September, so they could see everything. Something wasn't right. The ropes holding the sails up had burned in two. But the sails were still unfurled, and the ship was now traveling at full speed toward the overloaded longboat. The sails seemed to be a solid sheet of fire as the boat came nearer. There was no wind pushing the boat. It was completely calm, but the boat kept moving closer and closer to the longboat.

The captain and crew could not escape. Their fate was sealed. The flaming ship rammed the longboat, sinking it, the treasure and the crew. The next day, the remains of the burned ship washed ashore on Ocracoke Island.

Every year on the night of the first full moon of September, the flaming ship appears out of nowhere and sets sail again. Are those who so brutally departed this world still trying to find their new world?

21

Carroll A. Deering

O f the hundreds of ships lost in the Graveyard of the Atlantic, none has received more attention than the *Carroll A. Deering*. The *Carroll A. Deering* was a five-masted schooner launched in 1919 from Bath, Maine. It measured 255 feet in length, was 44.3 feet wide and registered at 1,879 tons. The *Deering* was the last large schooner constructed by the G.G. Deering Company and was named for the owner's son. It was equipped with Oregon masts measuring 108 feet long with topmasts measuring 46 feet. The *Deering* had a bathroom and cabins lit by electricity and heated by steam.

On January 31, 1921, the *Carroll A. Deering* was seen up on the Diamond. All sails were set on all five masts, but something was wrong. There was no crew. It had been abandoned. The *Carroll A. Deering* would become known as the ghost ship of the Diamond.

In September 1920, the *Deering*, under the command of Captain William Merritt, set sail from Boston, Massachusetts, bound for Buenos Aires, Argentina. Captain Merritt became ill and put in at Lewes, Delaware, where the *Deering* was taken over by Captain W.B. Wormell. Under the command of the new captain, the *Deering* headed to South America. It left Rio de Janeiro on December 2, 1920, en route to Norfolk, Virginia.

At 6:30 a.m. on January 31, 1921, Surfman C.P. Brady, a lookout at Cape Hatteras Coast Guard Station, spotted the *Deering* on Diamond Shoals. Two rescue boats with lifesavers from Big Kinnakeet, Cape Hatteras, Creed Hill and Hatteras Inlet lifesaving stations were sent to rescue the crew. One

report stated that it had been abandoned in a hurry. All lifeboats had been removed, and a ladder was hanging down the side of the ship.

The following day, February 1, 1921, the Coast Guard cutter *Seminole* was sent out from Wilmington, North Carolina. On February 2, the cutter *Manning* and a wrecking tug headed to the *Deering*. Due to rough seas, it was four days later, on February 5, when the *Deering* was finally boarded. What the boarding party found left them wondering what happened on the *Deering*. All personal belongings, key navigational equipment, certain papers and the ship's anchors were missing. The steering gear was disabled, charts were scattered about and food was fixed in the galley and on the stove.

The Coast Guard attempted to salvage the vessel but was unable to since the *Deering* could no longer float. Three weeks later, the ghost ship was dynamited.

As with any strange occurrence, there are theories and rumors. Mutiny, the murder of Captain Wormell and piracy were some of the speculations. A Buxton resident, Christopher Columbus Gray, reported that he found a bottle with a note in it on the beach that pirates had boarded the ship. It was later determined that the finder had written the note. Another theory is abandonment at sea. The crew realized that a storm they encountered off the lower Carolina coast had damaged the ship, abandoned ship in panic and drifted out to sea and certain death.

The last known point of sighting and communication was at Cape Lookout, North Carolina. As the ship passed Cape Lookout Light Vessel the day before it ran aground, a crewman had shouted through a megaphone that the ship had lost its anchor. No trace of the ship's crew, log or navigational equipment was ever found.

Despite extensive investigation by the U.S. government, no explanation was ever found for the crew's disappearance. The investigation came to an end in 1922 with no official explanation. The man placed in charge of the investigation was Lawrence Richey, assistant to Herbert Hoover.

Some chroniclers of sea mysteries place the blame on the Bermuda Triangle. Interestingly, nine other ships disappeared around the same time and in the same area as the *Carroll A. Deering*. None of the crew from any of the ships was ever found.

Haunted Lighthouses

When it comes to haunted buildings, lighthouses are among the most popular. For some unknown reason, lighthouses seem to be perfect buildings for these ghostly tales. No one knows what it is about a lighthouse that attracts these unearthly visitors.

Most lighthouses are extremely old structures surrounded by a lot of tragic deaths. Lighthouses mark coastlines that are considered dangerous. Thousands of ships and many of their passengers and crews have met their untimely deaths along these shores. Many people believe that the lighthouse hauntings are because the lighthouse is one of the last things they see. Even after death, they're trying to reach safety. The area surrounding the lighthouse and some of the buildings are also haunted. Some believe that in certain instances, a lighthouse keeper who died there is still trying to keep the light burning.

Cape Hatteras Lighthouse

The black- and white-striped Cape Hatteras lighthouse is the world's tallest lighthouse, standing at 208 feet tall. It is one of the most recognizable lighthouses in the world and North Carolina's most famous. The light spans twenty miles out onto the ocean. The lighthouse has 257 steps reaching to the top.

It was constructed between 1868 and 1870 at a cost of over $150,000. Nearly one hundred laborers—paid $1.50 per day—were hired to build it. Over one million bricks were used in the construction of the Cape Hatteras Lighthouse. On December 16, 1870—another source says December 1, 1870—the lighthouse's first-order Fresnel lens was activated by keeper Benjamin C. Jennet.

The current lighthouse is the second lighthouse to service Hatteras Island. The first lighthouse was completed in 1803 and stood ninety feet tall.

The second Cape Hatteras Lighthouse protected the water off Hatteras Island for over one hundred years. In the early 1990s, the lighthouse faced a new problem, beach erosion. After years of careful planning to move the lighthouse, all the details were worked out. In 1999, the Cape Hatteras Lighthouse and buildings were moved 2,900 feet inland. The moved started on June 17, 1999; it took twenty-three days to move the lighthouse. At 208 feet tall, the Cape Hatteras Lighthouse ended up being the tallest brick structure in history to be moved. The lighthouse has a well-stocked gift shop.

The Cape Hatteras Lighthouse was a center of conflict during the Civil War. The Confederate army wanted it destroyed to keep Union ships from

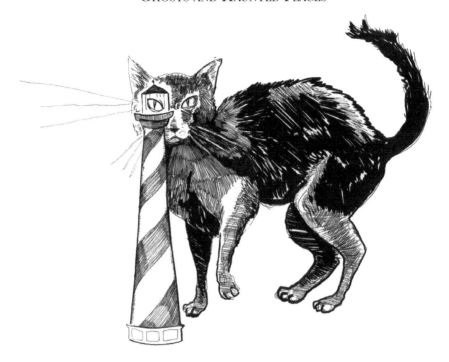

benefitting from it. The Union army wanted it protected. In 1861, defeated Confederate troops retreated, taking the Fresnel lens with them. In 1862, the lighthouse was relit with a second-order Fresnel lens.

In 1879, the lighthouse was struck by lightning, and the tower cracked. This resulted in a metal rod being used to link the tower's ironwork to an iron disk buried in the ground. In 1937, the Cape Hatteras Lighthouse was transferred to the National Park Service, and in 2002, it was discovered that the current Fresnel lens is, in fact, the original lens used before the Confederate army removed it.

Lighthouses are full of history and strange stories. One of the strange stories surrounding the Cape Hatteras Lighthouse is that of the *Carroll A. Deering*. On a winter morning in 1921, the ship was stuck off the shore on Diamond Shoals, North Carolina, with sails up. When the Coast Guard boarded the ship, rescuers found it abandoned. People have reported hearing screams from just offshore as darkness was settling in or as daylight was just beginning. The source of the screams has never been found.

Another apparition to haunt the lighthouse is the lighthouse keeper's big black cat. Guests have reported the cat running by them or brushing up against their legs. If they try to pet the feline or pick it up, the cat just vanishes. The cat story goes back somewhere in the neighborhood of one

hundred years. The cat appears inside and outside of the lighthouse and moved with the lighthouse as well.

The ghost of an old man named Bob, wearing a yellow raincoat, is reported to haunt the lighthouse. He has been seen inside the lighthouse and sitting on a bench nearby.

Phantom ships, ghostly sailors and a few ghostly pirates have been reported in the water and on land around the lighthouse area.

A female apparition has been seen for many years. Some believe it's the ghost of Theodosia Burr Alston. The female ghost roams the grounds around the lighthouse.

Then there is the gray man, who has been appearing since the early 1900s, warning people of an approaching hurricane. Many believe the man was a sailor named Gray who lived near Cape Point. The legend is that he drowned when his ship was caught in a hurricane. They say he appears out of nowhere and verbally warns people of impending doom, then vanishes as quickly as he appeared.

Ocracoke Lighthouse

I n 1585, a group of English explorers wrecked their ship in Ocracoke Inlet. That shipwreck put Ocracoke Inlet on the map. Two centuries later, Ocracoke Inlet was one of the busiest inlets on the East Coast, the primary waterway to the inland ports of Elizabeth City, New Bern and Edenton, North Carolina. It was then known as Pilot Town because in the 1730s, it was settled by ships' pilots, who steered the ships through the channels.

With the large amount of ship traffic through Ocracoke Inlet, the U.S. Lighthouse Service realized that a lighthouse was needed there. In 1794, on twenty-five-acre shell-covered Shell Castle Island, work began on the lighthouse. A wooden pyramid-shaped tower was completed four years later. A small house for the lighthouse keeper was built nearby, and as time went on, wharves, more houses, a gristmill and other buildings were built in the area.

Twenty years later, due to the shifting of the channel, the lighthouse had become obsolete. In 1818, the lighthouse and the lighthouse keeper's house were destroyed by lightning. In 1822, the federal government bought two acres of land for the new lighthouse at the south end of Ocracoke Island for $50, and work began on a new beacon. The lighthouse was completed in 1823 at a cost of $11,359.

The lighthouse is seventy-five feet high, with a diameter of twenty-five feet at the bottom and twelve feet at the top. The walls are five feet thick at the bottom and two feet thick at the top and made out of solid brick.

An octagonal lantern on top houses the light beacon. The outside of the lighthouse is solid white. In 1854, a fourth-order Fresnel lens was installed.

Early in the Civil War, the lens was dismantled by Confederate troops, but it was reinstalled by Union soldiers in 1864.

The present light is eight thousand candlepower and can reach fourteen miles. It is now fully automated, and the U.S. Coast Guard oversees the operation of the light. It is the second-oldest operating lighthouse in the nation. The double lighthouse keeper's house was completed in 1929 along with a generator house. It is North Carolina's oldest operating lighthouse.

Ocracoke Island is believed to be very haunted. Theodosia Burr Alston lost her life when her ship sank just off the North Carolina Outer Banks. Over the years, people have claimed to see her around the Ocracoke Lighthouse wearing a flowing white dress. She is often seen wet and sometimes with seaweed in her hair.

An old lighthouse keeper wearing black and gray striped pants and a white shirt has been seen around and inside the lighthouse. He has a beard and long hair tied back with a string. Some reports say he has been known to just walk right through people.

A girl in a light-blue dress has been seen near the lighthouse. At times, she has been seen walking after a thunderstorm. She has dark, flowing hair and fair skin. She has even talked to people but vanishes when they ask her questions. No one has been able to identify this mysterious young girl.

Currituck Beach Light Station

S ome sources refer to it as Currituck Beach Light Station, and others call it Currituck Beach Lighthouse. The Currituck Beach Lighthouse is distinct among the lighthouses along the Outer Banks of North Carolina. One unique difference is that the Currituck Beach Lighthouse shows off the natural red bricks used in its construction. Located in historic Corolla Village, the lighthouse towers above the northern Outer Banks. The Currituck Beach Lighthouse has had an uneventful life, no Civil War skirmishes or being threatened by an angry encroaching ocean or any other near catastrophes.

On March 3, 1873, Congress appropriated $50,000 to start construction on a lighthouse. After the site was purchased, North Carolina gave jurisdiction to the federal government. In 1874, another $70,000 was earmarked for the project, and in 1875, another $20,000 was given to complete the lighthouse.

Dexter Stetston began work on the 162-foot tower in 1874. Well over one million bricks were used to build the tower. On December 1, 1875, the lighthouse was illuminated for the first time by its first head keeper, Nathanial G. Burris. Three keepers and their families shared a Victorian Stick-style duplex.

The Currituck Beach Lighthouse was known as a first-order lighthouse, meaning it housed the largest of seven Fresnel lenses. The tower's first-order Fresnel lens, illuminated by a mineral oil lamp, was visible for eighteen nautical miles.

On November 5, 1886, the keepers and two assistants were in the lantern room when they felt an earthquake shake the lighthouse. There was no damage to the lighthouse, as the tremors they felt were only aftershocks from the earthquake that destroyed Charleston, South Carolina, two months earlier.

In 1939, the lighthouse was automated, the Coast Guard took over the U.S. Lighthouse Service and the light keeper became a thing of the past.

During World War II, Coast Guardsmen were stationed at the lighthouse to patrol the nearby beaches. The lighthouse's usefulness declined after the war, and by the 1970s, it had been abandoned and was falling into a state of disrepair.

In 1980, a group of concerned citizens worried about the possible loss of the lighthouse formed the Outer Banks Conservationists Inc. They leased the property in order to try to save these historic buildings. The original keeper's house is now in the National Register of Historic Places, and the lighthouse has been returned to its former beauty. It cost over $1.5 million—from private sources—to restore and maintain the property.

The National Historic Lighthouse Preservation Act of 2000 made Currituck Beach Lighthouse, among others, available to federal, state and local agencies, nonprofit corporations and community development organizations. Outer Banks Conservationists Inc. and the Currituck County Board of Supervisors filed applications for the lighthouse's ownership in February 2003, and in March, the National Park Service recommended the Outer Banks Conservationists Inc. be awarded the lighthouse. A war started over the recommendation, known as the "Fight for the Light." Currituck County, with the help of Congressman Walter Jones, appealed the decision. The deed to the lighthouse was signed over to the Outer Banks Conservationists Inc., rewarding the organization for its years of restoration work on the lighthouse.

Every night, from dusk to dawn, the twenty-second flash from Currituck Beach Lighthouse illuminates the sky. The light is on for three seconds and off for seventeen seconds.

The lighthouse was opened to the public on July 21, 1990. Visitors can climb the 220 steps of the winding staircase to a great view at the top. The Currituck Beach Lighthouse is a member of Currituck Heritage Park, Historic Corolla and the Historic Albemarle Tour.

A few facts about the lighthouse: it is 220 steps to the top, 158 feet to the focal plane of the lens, 162 feet high, approximately 1 million bricks used in the construction, the thickness of the wall at the base is 5 feet, 8 inches and the thickness of the wall at the parapet is 3 feet.

Sources say that the Currituck Beach Lighthouse is one of the most haunted spots in North Carolina. The north room of the keeper's house has a strong presence of two women. One is believed to be the ghost of a keeper's wife who died of tuberculosis. The other ghost is believed to be Sadie, a keeper's daughter, who drowned when she was snatched out to sea by a rip current. The next day, her lifeless body washed up on shore and was found by several fishermen.

A lady friend of the family was visiting the keeper and his family and staying in the north room.She became seriously ill with an unknown illness and passed away in the north room. Could she still be haunting the north room?

Providence Church

Since the nineteenth century, Providence United Methodist Church has been known as the church moved by the hand of God.

In 1876, the good citizens of Swan Quarter, North Carolina, wanted to build a church for their worship services. A committee was appointed, and the search began. The committee searched in vain for the perfect location for the church. But the citizenry finally chose a piece of land that they thought would be the perfect location for the church: the highest ground around. When built, the church would be visible to everyone in the community.

The committee approached the landowner, Samuel R. Sadler, who quickly turned down the offer. A little frustrated by not being able to get that piece of land, the committee members had no choice but to look elsewhere. They finally decided on a parcel of land in the village near the waterfront. The congregation accepted the gift of a lot behind the courthouse.

After months of working on the building, the church was nearing completion, and on September 16, 1876, the church was dedicated. It would soon be touched by the hand of God. Without warning, a violent hurricane blew in from the ocean and hit the village hard. Swan Quarter flooded as the tide from Pamlico Sound rose and the heavy rain continued. The little village was under about five feet of water. As the tempest winds blew their mightiest, the foundation of the new church wouldn't hold. The church was lifted off its foundation by the mighty rushing water and floated away. The journey had begun. The Methodists were astonished as they watched in disbelief as a miracle was being performed right before their eyes.

Heading north, the church traveled by houses and businesses, then turned east. The church continued on as if being piloted by a ship's captain. The building made its way to the exact spot the congregation had previously tried to buy. The church turned itself around so it would be facing Main Street, then settled down onto the chosen property. The congregation believed the church was moved by divine intervention.

By 1881, the church had acquired the land. It was sold to the church, not given by the owner with trembling hands immediately after the miracle happened, as some sources say.

It was originally called the Methodist Episcopal Church South after it found its new home. The name was changed to the Providence Methodist Church.

The church marker reads:

"moved by the hands of God"
September 16–17, 1876
Swan Quarter, North Carolina
Hyde County

Membership had grown considerably by the 1900s, and in 1913, a brick sanctuary was built to replace the original church. The small wood frame church sits behind the brick church on Main Street and serves as classrooms.

The church is one of ten historic sites on the Hyde County Talking Houses and Historic Places driving tour.

Swan Quarter, named for the many swans that once frequented the bay, was established in 1812. In 1836, Swan Quarter became the county seat of Hyde County.

Wash Woods Station

The U.S. Coast Guard Station Wash Woods was originally known as the Deal's Island Station. Built in 1878, it was renamed Wash Woods by 1883. Prior to 1914, Wash Woods Station sat on land for which the government had no title. In 1914, the federal government claimed title to the land occupied by the station.

Malachi Corbell saved two fishermen when their boat capsized near Caffeys Inlet, North Carolina, in June 1877. Corbell was the first member of the U.S. Life-Saving Service to earn the Congressional Life Saving Medal.

The station was established by an act of Congress on June 18, 1878, and the first officer in charge was appointed on December 9, 1878. Calvin B. Cason was chosen to run the station. He was dismissed from service on December 27, 1881. On January 1, 1879, the first crew was engaged. On September 21, 1882, Malachi Corbell was appointed. He died in service on September 17, 1908. Valerious Knight was appointed on October 20, 1908, and was still serving in 1915.

In 1915, the United States Life-Saving Service merged with the Revenue Cutter Service and was renamed the U.S. Coast Guard.

Wash Woods was no. 166 in the chain of stations along the Atlantic coast.

The original main building had eight rooms, two bathrooms, a separate galley and a pair of cisterns built on the northwest corner of the station. The cisterns were used to collect water from the roof and supply the guardsmen with water. A small lookout tower was built on the ocean side.

During World War II, Wash Woods was home to about thirty guardsmen. The lookout tower was in constant use, as armed men patrolled the beach. After World War II, Wash Woods reverted to the original number of people it had before the war until 1949. It had only a single caretaker after that. It was abandoned in 1954 or 1955.

In the years following, Wash Woods Station served as a private vacation home.

In 1988, Doug and Sharon Twiddy bought the Wash Woods Station and surrounding outbuildings. They began restorations and completed them in 1989. The original tower was built in 1917 and destroyed by a hurricane in 1933. After the plans were found in the archives in Washington, D.C., a replica of the tower was built in 2011.

Wash Woods Station serves as a Twiddy and Company Real Estate office. It is believed to have a resident ghost called Mose. Old-timers who pulled duty there claim they have seen, heard and felt things that they can't explain. Some people who stayed there when it was part of a property management program reported strange happenings such as lights coming on and going off by themselves and doors slamming shut while nobody was there.

USS *North Carolina*

The USS *North Carolina* was laid down on October 27, 1937, by the New York Naval Shipyard in Brooklyn, New York. It was the first battleship constructed in sixteen years. The *North Carolina* was launched on June 13, 1940, and commissioned on April 9, 1941.

The propulsion system was eight Babcock & Wilcox boilers and four General Electric geared turbines. The ship had four propellers and 121,000 horsepower.

The battleship was 728.86 feet long and had a draft of 35.6 feet. Its beam was 108.4 feet long. *North Carolina* had a speed of twenty-seven knots (thirty miles per hour), and the displacement was approximately 46,000 tons fully loaded.

Its armament consisted of three Vought OS2U Kingfisher floatplanes; two catapults; nine MK-6 sixteen-inch, .45-caliber guns in three triple mounts; twenty five-inch, .38-caliber guns in ten twin mounts; 40mm guns in quad mounts; and seventy-six 20mm guns. *North Carolina* also received the early RCA CXAM-1 radar.

The USS *North Carolina* was under the command of Captain Olaf M. Hustvedt. In wartime, it carried a crew of 2,339; in peacetime, 1,880 crewmen manned the battleship, including 144 commissioned officers.

The USS *North Carolina* was the lead ship of the North Carolina–class battleships. It was the fourth warship in the U.S. Navy to be named after the state of North Carolina. The USS *North Carolina* received so much attention that it received the nickname "showboat."

The first of ten fast battleships to join the American fleet in World War II, the USS *North Carolina* participated in every major naval offensive in the Pacific theater. It earned fifteen battle stars. On September 15, 1942, a Japanese torpedo hit the battleship's hull. A quick response from the crew allowed the ship to keep up with the American fleet. In all, the USS *North Carolina* carried out nine shore bombardments, sank an enemy troopship and destroyed twenty-four enemy aircraft.

In April 1943, *North Carolina* was in Pearl Harbor to receive advanced fire control and radar gear.

After years of fierce battles during World War II, the USS *North Carolina* sailed home with passengers from Okinawa, Japan. It reached the Panama Canal on October 8, 1945, and anchored at Boston, Massachusetts, on October 17, 1945.

After inactivation, the USS *North Carolina* was decommissioned in New York on June 27, 1947, and struck from the navy list on June 1, 1960. The battleship was transferred to the people of North Carolina on September 6, 1961. On April 29, 1962, it was rededicated at Wilmington, North Carolina, as a memorial to the North Carolinians of all branches of service who lost their lives in World War II.

In the mid-1980s, under President Ronald Reagan, many of the ship's systems were scavenged for parts to recommission the Iowa class of battleship. In 1986, the USS *North Carolina* was declared a National Historic Landmark.

The memorial is administered by the Friends of the Battleship North Carolina, established on December 10, 1986. The memorial operates tax free, relying on its own revenue and donations.

Visitors can tour the battleship on self-guided tours. There is an admission charge for the tour, though. The tour takes about two hours, and visitors can view one of the remaining Kingfisher floatplanes displayed near the stern. Step back in time and let history come alive through the crew's stories. A roll of honor in the wardroom lists the names of all the North Carolinians in all branches of the service who gave their lives for our country in World War II. The USS *North Carolina* lost ten men and had sixty-seven wounded in action.

There is a gift shop so you can pick up a souvenir from your visit, a visitors' center and a picnic area for your enjoyment.

Several restoration projects are planned for the USS *North Carolina*.

The Ghosts

Ten men lost their lives on the battleship during battle. Some believe that several of these men decided to stay on the battleship. When the ghosts of the ship become active, they certainly make themselves known.

A young blond-haired man has been seen wandering around the passageways. Another man has been seen looking through the portholes. Hatches and doors open and close by themselves; lights turn on and off without anyone there. Witnesses have reported seeing things move without anyone's help. People have heard voices when no one is talking or no one else is there. One report said that one of these unearthly guests hitched a ride with an unsuspecting visitor. Footsteps have been heard, and some have experienced cold spots.

Some refer to the USS *North Carolina* as the battleship by day and the ghost ship by night. People have reported seeing ghosts, while others experience strange feelings. Some visitors have reported seeing the ghosts of sailors on duty, and others say they have been touched while no one else was around.

Some refer to it as the world's most haunted battleship. Some reports say a young blond-haired man has a rude habit of just disappearing in front of your eyes. There are reports of batteries in multiple pieces of electronic equipment dying at the same time. Ghost hunters report the most consistent ghostly activity is in the shower room.

Two paranormal investigators reported that they chased a person or what they thought was a person through the ship, up and down stairs, and finally cornered him in a room—only to find no one there. There are reports of whispering coming from somewhere inside the ship when no one is around.

I spent a few hours on the USS *North Carolina* many years ago, but unfortunately, I did not experience anything unusual.

Aboard the Battleship *North Carolina*

he following is a firsthand account from Michael and Kelly Broskey, ghost hunters:

On November 21, 2015, my wife Kelly and I of Phasma Paranormal were privileged to take six guests on board the Battleship NC for a twelve-hour nighttime lockdown. This is our account.

First entry (lights on):

As we ascended the gangplank to the battleship, my wife pointed out a Kingfisher airplane to our guests. We were aware that on April 6, 1945, Eldon Means was killed in a Kingfisher recovery accident. We were not sure if this was the same plane, but our video cameras picked up orbs, mists and light anomalies around this area all night. Next, we moved directly to the turret closest to our entry. As our guests shimmied up the ladder into the turret, our high-definition video recorder picked up an EVP, or electronic voice phenomenon. A voice could be heard on our video saying "stupid." We later confirmed with our guests that no one had said this. We proceeded through the rest of the ship with the lights on to familiarize our guests with the narrow corridors and "hot spots." There was no further activity until we came back out on deck toward the bow. Once upon deck, we checked our MEL meter, which measures the electromagnetic field and temperature. Our MEL registered a 5.2 MG spike and a twenty-degree temperature change

somewhere below deck. These are significant readings, and many believe they indicate the presence of spirits. It was at that time that one of our guests told us that he had felt a "cold spot." Another had reported that she felt "something funny" in the barbette. As we proceeded toward the bow, our REM began to light up and beep. The REM utilizes a mini telescopic antenna to radiate an independent EM field around the device. It is believed that spirit energy can manipulate, distort and influence such an EM field. We could find no reason for this event.

Second entry (lights off):

A group of our guests in the galley area, in complete darkness, had an ITC device which responded with the words "story" and "Paul." Directly in front of them was a plaque with a small story, and the name of the storyteller was, in fact, Paul. As we began to shoot in IR, several orbs began to fixate on a female investigator's legs. When activity decreased, we suggested that the spirit might want us to leave the female investigator by herself. At that moment, the device responded with the word "solo."

As we moved on to the forward barbette, another one of our female guests reported feeling uncomfortable. She said she felt like there were more than just us present. She felt like there was an unseen presence. The left side of her neck and face tingled as if an electric charge was passing over. Taps were heard on the metallic hull as if something was letting us know it was present. Little did we know, but that investigator and her group would leave suddenly from the Battleship due to a continued presence which seemed to follow the one investigator and cause her distress. An interesting spirit box session on the bridge seemed to indicate that some kind of intelligent spirit was communicating. Several key facts were relevant and later validated.

Third entry (lights still off):

After recharging and dumping our data files, we reentered the Battleship a third and final time for the night. One of our teams of guests decided to get some sleep. With their sleeping bags on tables near the galley, they fell into a restless sleep. The rest of us elected to make the long path encompassing half of the ship and five levels. In engineering, we shot video, took digital recordings and used a variety of ITC devices. Activity seemed to have died down as we approached the witching hour. Wrapped in the darkness with the hulking turbines and tubes, we thought we heard our other party

approaching. Clearly we heard their descent down the iron ladders and their footsteps clanging on the metal. Furthermore, to verify that this was them, we perceived the unmistakable and distinct sound of one of our ITC devices. It is hard to mistake the computerized voice of the Ovilus III. All but one investigator moved away to greet the other team obviously coming down. One investigator who remained behind, peer through a tiny LED screen into the total blackness. As he went to fish a battery from his vest, he quickly looked at the screen and saw who he thought to be a young, man from the other team. He had an odd paleness about him as he moved through a tight area not easy to navigate. The investigator glance down to check his battery and when he looked up the figure was gone. Chills and adrenaline coursed over and through his body. It was at that time that he realized that he had seen what must have been a ghost. He called out in alarm to his companions who had moved away. When they returned to hear his shocking tale, he was further mystified to discover that the other team had not in fact descended down into engineering. It seemed as we approached 3:00 a.m., at least one spirit decided to manifest in a remarkable way.

We moved on to sickbay. The night and the late hour were taxing our senses and stamina. As we reached sickbay, three of our guests needed to take a restroom break. Later, a text would somehow get through the iron haul informing us that they had left quickly because one of their group felt very distressed. Now it was just the two lead investigators. The female lead investigator began shooting a thermal video camera down the long, dark hall of sickbay. The thermal video shows temperature and the orange and blue colors danced across her LED screen. Creaks and taps began to increase in frequency. Next, footsteps began to sound in the narrow passage. As she looked down the hallway through the LED screen she saw a shadow pass over a reflection at the end of the hall. The intensity in sickbay elevated as electricity and chills moved through the two investigators alone in the belly of the mighty ship. "Did you see that?" Rarely did this investigator speak with such emotion. A sort of dread invaded both investigators. Noises, taps and footsteps continued to sound around them. It was unknown at the time, but later high definition night vision video would reveal a flurry of orbs and mists in the sickbay passage. The male investigator decided to move down a parallel passage and come around to the spot where the shadow figure was seen. He made that track many times before in the light. Total darkness provided a totally different walk. As he walked by himself down the parallel hall, he felt watched and followed. His nerves stressed as he could hear footsteps behind him. Finally, he reached the spot down the

hallway from the other investigator. They called out in relief to each other feeling like they were children again. Neither would forget that moment.

As the night came to an end and dawn approached, the cumbersome task of hauling the equipment back to the vehicle confronted us. We were silent in our reflection of the night's events, but the Battleship had one more surprise in store for us. As we began taking the equipment back to the vehicle, we were shocked to discover that a higher than usual tide was rushing in. It literally began encircling us with a rush of water. Were the spirits of the Battleship North Carolina *trying to keep us there? With great effort, we waded through the water, packed our equipment and headed home. The rushing water lapped at our tires as we pondered those spirits on board that great ship. Perhaps they felt caught like the great ship herself and longed to be free at sea and hear the waves against her mighty hull once more?*

Fort Fisher

Construction on Fort Fisher at Federal Point started in the spring of 1861. Fort Fisher began as several sand batteries with fewer than two dozen guns. In April, Major Charles Pattison Bolles was the first to work on the batteries north of the inlet. Fort Fisher was built to protect the port city of Wilmington, North Carolina, from the Union during the first sixteen months of the Civil War. Many commanders were transferred in and out of Fort Fisher. After Bolles was transferred to Oak Island, Captain DeRosset oversaw the strengthening of the batteries, now named Battery Bolles in honor of Major Charles Pattison Bolles. In July 1862, Colonel William Lamb began to expand Fort Fisher.

By 1864, Fort Fisher boasted a defense of over a mile of the sea and protected Wilmington, North Carolina, which was the last trade stronghold of the South. Fort Fisher guarded the Cape Fear River, allowing blockade runners to take in necessary provisions to Wilmington and to General Lee's Confederate army.

Wilmington was the last of the Confederate trade ports to remain open during the waning days of the Civil War. Fort Fisher was virtually impossible to defeat, and that allowed Wilmington to stay open.

In December 1864, two major battles were fought at Fort Fisher. The first attack came on Christmas Eve 1864. During the next three days, the fort repelled the attacker but lost twenty-eight men and more missing, captured or wounded, but Fort Fisher remained steadfast.

By January 12, 1865, the fort was being bombarded from the sea and land, and on January 15, General Whiting was forced to surrender to Major General Terry. Fort Fisher was officially defeated and with it the Confederate South. A few months later, the South would surrender.

During the attack on Fort Fisher, the Confederate army lost over 2,200 men. Federal forces lost over 1,500. General Whiting was taken to a Union prison camp and left to die. He died in 1865 at Fort Columbus, New York Harbor.

Today, Fort Fisher is a national landmark, but not much of the original fort is left. You can take a tour and walk among the mounds that once guarded the last Southern stronghold. Fort Fisher is located off Highway 421 near Kure Beach, North Carolina. It is open to the public only during posted hours. No pets are allowed on the grounds. Do not trespass after hours or in areas not open to the public.

With so much death and violence associated with Fort Fisher, you might expect a ghost or two to be lingering around in the shadows. Are these ghostly visitors trapped in an earthly realm at Fort Fisher? Are they remaining to complete their unfinished tasks? Are they still defending their fort? Could these wandering souls be just a bit of history that each of these soldiers left behind? Whatever the answer is, if you look hard enough or listen close enough, you might have an experience with an unearthly visitor.

There are quite a few legends that go along with Fort Fisher. Fort Fisher's best known ghost is the ghost of General Whiting. He has been seen on the parapet and walking the grounds still in command of his fort.

The first recorded sighting was in the early 1900s, a Confederate soldier standing watch in the woods north of the fort. Another one is an unidentified apparition going from the ocean to the fort. A man dressed in gray has also been seen on the grounds. Soldiers have been reported by park employees, visitors and paranormal investigators.

Then there's the sound of footsteps on the wooden walkways when there's no one there. There have been reports of the sound of battle over the ocean at night and the sounds of gunshots have also been reported.

There have been other ghostly happenings around the fort. A door opens itself despite the fact that it's locked. In one area, flashlights mysteriously went out, then came back on. Some cameras jam and refuse to advance the film or release the shutter. New batteries die for no reason.

There's the report of the man standing on the fourth knoll witnessed by three paranormal investigators. The sighting was accompanied by a drastic

drop in temperature from sixty-eight degrees to forty-three degrees. The man slowly faded away while the paranormal investigators watched.

There was the report of a scream and the faint sound of help coming from the beach when no one was there.

Then there's the mysterious death of hermit Robert Harrill. Some believe that he was murdered, while the official cause of death was natural causes. Some still question the accuracy of the police investigation. Some believe he is still roaming the land he called home.

Ghost of Blackbeard

Edward Teach, aka Blackbeard, roamed the Atlantic Ocean from around 1716 until 1718. For two years, Blackbeard would terrorize seafaring men on the Atlantic Ocean and in the Caribbean, looting ships from the West Indies to the Carolinas. He had a reputation for unbridled ferocity.

Blackbeard and his band of pirates ambushed ships carrying passengers and cargo. They would attack in the dim light of dawn or dusk when it was hard to make out the ship's flag. Blackbeard often determined the victim ship's nationality, then raised that country's flag. The unsuspecting ship would assume the pirate ship was friendly. At the very last moment, the pirates raised Blackbeard's flag.

When Blackbeard went into battle, he strapped multiple pistols and cutlasses to his body. Then he would weave fuses into his long black beard and set them on fire. This would strike fear in the hearts of anyone. Most captains would surrender without a fight. Many would surrender when they saw Blackbeard's flag. The pirates would then board the ship, take the crew hostage and ransack the ship looking for treasure. There is no record that he ever killed anyone.

Of all the pirates sailing the seas over the past three thousand years, Blackbeard is the most famous. He was British and probably born before 1690. His first experience as a young seaman was serving on a British privateer based out of Jamaica. Privateers were hired by governments to attack enemy ships.

Queen Anne of Britain allowed Edward Teach to attack French and Spanish ships during the War of Spanish Succession. Blackbeard was

allowed to keep all the acquired goods and would soon become the captain of a ship that he had stolen.

Blackbeard once took over a cargo ship carrying wealthy passengers as it left Charles Town, South Carolina. He threatened to kill all of them if the people of Charles Town did not meet his demands: a medical chest filled with medicine. With only minutes to spare, the chest was delivered to Blackbeard.

In the fall of 1718, Blackbeard returned to Ocracoke Island to host a pirate get-together. He was always welcome there because he would sell his stolen treasure to the locals at low prices.

News of the meeting reached the governor of Virginia, Alexander Spotswood. Governor Spotswood decided it was time to bring an end to Blackbeard's reign of terror forever and sent two ships commanded by Lieutenant Robert Maynard of the Royal Navy to Ocracoke Island. When the two ships arrived, Blackbeard knew he was trapped. The next morning, Blackbeard ordered his crew to set sail when the navy ships started moving. A fierce fight ensued. One navy ship was destroyed, and both had run aground on a sandbar. Maynard ordered his men to throw everything not needed overboard, and the surviving ship floated free of the sandbar. The battle continued. Maynard ordered his men below deck, and Blackbeard, thinking the men were dead, boarded the ship. Suddenly, Maynard's men rushed from below deck. There was a fierce battle, and Blackbeard and Maynard came face-to-face. Both fired their pistols; Blackbeard missed Maynard, but Maynard hit his target. Although wounded, Blackbeard managed to take out his cutlass and cut off Maynard's sword blade. Just in time, a navy seaman came up from behind and cut Blackbeard's throat.

On November 22, 1718, Blackbeard's reign of terror came to an end. His head was cut off and hung from the bowsprit of Maynard's ship as a warning to other pirates. His headless body was thrown overboard.

There are a number of legends about Blackbeard's ghost. One story is that Blackbeard haunts the spot known as Teach's Hole. Another legend says that Teach's headless body swam around Maynard's ship three times before sinking. Many people have reported seeing a strange light moving beneath the water in Teach's Hole. Some have reported hearing a horrible

roaring coming from the cove. On nights when the wind is blowing and the rain is pouring down, some people say they have heard an unearthly noise like a human in awful pain, calling out, "Where's my head?"

Ever since the *Queen Anne's Revenge* was discovered, archaeologists and historians have been working on recovering and restoring artifacts from the ship. In recent years, researchers have discovered new evidence in the archives of England, France and the Americas. Many of the discoveries shed new light on the final months of Edward "Blackbeard" Teach's life.

Ghost of Roanoke Island Inn

Constructed in the 1860s by Asa Jones and wife, Martha, the Roanoke Island Inn is a picturesque little bed-and-breakfast in the small coastal town of Manteo. For more than a century, its second-floor porch has overlooked the scenic Roanoke Marshes Lighthouse. The Roanoke Island Inn has more than doubled in size from its original structure. The inn is now owned by John Wilson, the great-great-grandson of Asa Jones.

The present Roanoke Island Inn offers its guests the privacy of outside entrances, a comfortable lobby and Manteo's acclaimed waterfront. There are shops, restaurants and all the friendliness a small town has to offer.

Along with the peacefulness comes a strange tale. The ghost of Roscoe Jones, the former owner of the Roanoke Island Inn and a Wilson family member, refuses to vacate the inn.

Roscoe Jones had been Manteo's postmaster for many years when one day he was notified by the U.S. Postal Service that his services as postmaster were no longer needed. Humiliated by being let go after his many years of dedicated service, he felt his life was over. Roscoe retreated to his house and shut himself off from the rest of the world. He retired to his room and wouldn't leave if anybody was in the house. When no one was around he would sneak down for his meals.

Not long after his death, the ghost of a man wearing a postal uniform was seen on occasion leaving or entering the front door. Sometimes people downstairs would get a glimpse of a shadow ascending the stairs. Guests

have reported hearing footsteps walking back and forth upstairs. Vases have been heard falling and breaking on the floor, blinds go up and down by themselves and a radio turns on and off on its own in room three. Room seven appears to have the most activity.

Ghosts of the Price-Gause House

O ne spot in Wilmington, North Carolina, that appears to be haunted and has been since it was built is the Price-Gause House. The Price-Gause House, 514 Market Street, was built on or near Gallows Hill at some point between 1843 and 1860, depending on the source material. One man reported that workers digging lines for pipes in that area in 1976 unearthed a number of bricked-in tombs. Alice Rheinstein Bernheim told the *Wilmington Morning Star* in 1957 that she found human bones while digging in the backyard. One source says that as many as 150 people were hanged at Wilmington's Gallows Hill.

There is not much documentation on public executions in New Hanover County prior to 1800. However, it appears that a lot of bodies were buried where the Price-Gause House was built.

When Dr. William Price decided to build his home on the site instead of building a separate office for his medical practice, he designed his home to be large enough for his office and living space. Immediately after the Price family moved into the house, strange things started happening.

People have heard someone walking on the stairs when no one's around. Some have even smelled pipe tobacco. An eerie tapping sound coming from the walls has been reported. Doors have been seen opening and closing by themselves.

One of the most active rooms is the upstairs office, which was used as a bedroom. It is not unusual for the windows in the upstairs room to frost up on summer nights. The word *help* can be seen in the frost. A

picture was taken of what looked like the ghostly figure of a person looking out the window. Chairs that rock themselves and kitchen items that have been moved around at night have been reported. One person claims to have seen and spoken to a woman in period clothes.

There's the story about James Peckham, who was supposedly hanged in the 1700s for the alleged theft of an expensive ladies' pocketbook. Peckham protested his innocence until the final seconds of his life. The ghostly spirit of James Peckham still haunts Gallows Hill trying to clear his name.

Other witnesses say while standing in the front door they have seen a smiling old man in clothes of a bygone era coming down the front stairs who vanishes.

In the middle of the night, Lynne Gause noticed an eerie chill in her bedroom and unseen hands trying to pull the covers off of her.

In October 1967, a ghost was captured on film. A misty human form can be seen walking down the stairs.

The Prices and their decedents, the Gauses, owned the house from its construction until 1968. The family did occasionally rent out the property.

From 1881 to 1899, it was home to Frederick Rheinstein. Edwin C. Holt lived there from 1902 to 1905. From 1968 to 1991, the house was home to the Greater Wilmington Chamber of Commerce. In 1990, Ballard, McKim and Sawyer Architects used the house as an office. Today Bowman, Murray and Hemingway Architects call it home.

34

Bellamy Mansion

In 1859, Dr. John Dollard Bellamy hired architect James Post from Wilmington, North Carolina, to build his new house. In May 1859, Post hired Rufus Bunnell as an assistant architect. No one knew whose idea it was to build such an elaborate structure. Certain elements point to Belle, Dr. Bellamy and his wife Eliza's first child. Belle had studied in South Carolina and found a home in Columbia that was similar in design and style. She shared her ideas with Dr. Bellamy and architect Rufus Bunnell. In October 1859, excavation on the site began, and the foundation was laid shortly afterward.

It took until early 1860 to complete the drawings, and by then, most of the building supplies, including Corinthian columns and various window drapings, had been ordered from New York.

The buildings on the Bellamy property would include a carriage house and slave quarters. Among the men working on the Bellamy home and other buildings were slaves from Wilmington, free black artisans and many other skilled carpenters from around the area. William B. Gould and artisans showed their skills on the wall plaster, moldings and the woodwork throughout the house.

Dr. Bellamy was interested in modern utilities and innovations and amenities not seen in many homes in the area. John Bellamy moved from South Carolina to Wilmington, North Carolina, to study medicine with Dr. William Harriss. Bellamy left Wilmington, North Carolina, in 1837 for two years to study medicine at Jefferson Medical College in Philadelphia, Pennsylvania.

John Bellamy would return to Wilmington in 1839 to marry Eliza Harriss and take over Dr. Harriss's medical practice after he met his untimely departure from this world. In July 1860, they were prepared to move into their mansion on Market Street. They had eight children ages one to nineteen. In 1861, Robert, their last child was born.

THE BELLAMY CHILDREN

Marsden Bellamy became an attorney.

William Bellamy became a doctor.

George Bellamy became a farmer and took over Grovely Plantation in Brunswick County.

Robert Bellamy became a businessman in the pharmaceutical industry.

John Bellamy Jr. became a politician from 1899 to 1903 and represented North Carolina in Congress.

Chesley Bellamy died at age twenty-one while attending Davidson College.

Elizabeth "Belle" Bellamy, the only daughter to marry and have children, married Jefferson Duffie of Columbia, South Carolina, on September 12, 1876. They had two children.

Eliza and Ellen Bellamy lived out their days unmarried in the family mansion.

No historic home comes without its resident ghosts. People have reported the entry door slamming and hearing different voices in the mansion. A local paranormal group said investigators recorded voices saying "Get out!" and "Who's that?" Both male and female voices were recorded. Sarah, the girl ghost, is quite talkative. Dr. and Mrs. Bellamy can be heard in addition to a child's laughter. Voices can be heard coming from the staircase and in the slave quarters.

35

Nell Cropsey's Ghost

The Cropsey family moved to Elizabeth City in 1898 from Brooklyn, New York, with their sixteen-year-old daughter Ella M. "Nell" Cropsey. Nell was a beautiful young lady and attracted many suitors. Nell began courting a local man, the sheriff's son, Jim Wilcox. He was five years older than Nell. Their romance spanned three years with no proposal from Jim, so Nell started flirting with other men.

In November 1901, with Thanksgiving coming quickly, the Cropseys planned a trip back home to Brooklyn. On the evening of November 20, 1901, Nell and Wilcox had a loud fight. Everyone in the house could hear the argument. By the end of the day, they had apparently made up to at least some degree. They stepped out of the house about 11:00 p.m. That was the last time Nell was seen alive.

Nell's sister Ollie heard something hit the back of the house. When she went out to check, she found the screen door broken. She went back inside to see if Nell was in bed. She was not. Ollie went on to bed, thinking nothing of it.

A neighbor woke everybody in the Cropsey house up, yelling that somebody was trying to steal the pig. Everyone rushed down to find the front door open. They realized then that Nell was not home.

On the night of November 20, 1901, Nell Cropsey disappeared from her home. Jim Wilcox was the last person to see her alive. The residents of Elizabeth City formed search parties to scour the area. They continued the search, but no evidence was found.

On December 27, 1901, two fishermen found her body in the Pasquotank River. The coroner's report listed cause of death as trauma to the head.

In another version of the story, Mrs. Cropsey noticed something floating in the Pasquotank River. She sent some boatmen to check it out, and it was Nell.

Jim Wilcox was the only suspect, and he was arrested on kidnapping and suspicion of murder. A mob went to the jail to take Jim out. The crowd kept growing until Governor Aycock sent a small reserve force to disperse the crowd.

Wilcox was tried twice before he was ultimately convicted. He was found guilty of second-degree murder and sentenced to thirty years in prison. Wilcox maintained his innocence to the end of his life. Governor Thomas Bickett pardoned Wilcox in 1920.

Wilcox spoke with W.O. Saunders, the editor of the Elizabeth City newspaper, and revealed everything he knew about the murder. Saunders planed to publish the details two weeks after the interview. Before the article could be published, both men died. Jim Wilcox killed himself in 1932, and shortly after Wilcox's death, Saunders died in a car accident.

People in the Cropsey house have reported lights going on and off by themselves and doors opening and closing when no one is around. Strange gusts of cold air have been reported moving through the house. The silhouette of a young woman has been seen moving through the house. A ghostly figure of a young woman has been seen looking out the upstairs window. Residents report that Nell Cropsey makes an occasional appearance in their bedrooms. Her ghost roams the halls, appearing and then disappearing in the hall and bedrooms.

The Cropsey house is a private residence. Respect the owner's privacy and don't trespass.

Dymond City Ghost Lights

The beginning of Dymond City was the formation of the Jamesville and Washington Railroad and Lumber Company. The lumber company began buying large tracts of timberland in Martin County in 1868. A railroad would make it easier to transport the cut logs. By 1877, the railroad was complete and named the J and W Line. It began taking passengers between Jamestown and Washington. The J and W soon become known as the "Jolt and Wiggle" because of the rough track.

Dymond City was a company town that came with the railroad. The railroad company owned the houses, and rent was paid to the railroad company. All needed supplies for everyday life were bought at the company store. The spelling Dymond City instead of Diamond City was probably because there was another town in North Carolina with the same name. By 1885, a hotel and post office had been built. Dymond City was a thriving town, and the lumber business was good.

By the 1920s, the population had begun to move away, and the post office closed. In 1927, a wildfire swept through the town, destroying the hotel, school and all of the houses. Dymond City was just a memory. The lumber company ceased operations, the railroad tracks were removed and the forest reclaimed its land.

Hikers along the old road that passed the city began seeing strange lights. Some witnesses reported the lights resembled the light of a lantern being carried by some unseen person. Others reported the light seemed to be trying to get people to follow it. One legend says the lights are the ghost of

a railroad man. Others say it's the spirit of the long gone train. As it moves closer to you, it gets bigger and brighter, like the headlight of a train. Others say it's the spirit of the town. The ghost lights of Dymond City can still be seen today. The lights vary in color from blue to orange and are usually seen about ten to fifteen feet above the ground.

Dymond City Road is off North Carolina 171 about ten miles south of Jamesville. The lights are usually seen along the last mile of the road before it dead-ends.

Another legend of the Dymond City Lights is that the conductor of a train had his head cut off when he stuck it out of the window. His spirit is still looking for his head.

Fort Macon

ort Macon State Park is located on the east end of Bogue Banks in Carteret County, North Carolina. It covers 423 acres. It was founded in 1936 and is under the management of the North Carolina Division of Parks and Recreation. Fort Macon is an International Union for Conservation of Nature (IUCN) Natural Monument. The fort is five-sided and constructed of brick and stone. It has seventy-six vaulted rooms enclosed by four-and-a-half-foot-thick walls.

The coast of North Carolina around Beaufort is vulnerable to attack from the sea. Beaufort was captured and plundered by the Spanish in 1747, then captured again in 1782 by the British.

North Carolina, realizing the need for coastal defense, decided the eastern point of Bogue Banks was the best spot for a fort to guard the entrance to Beaufort Inlet.

Fort Hampton was built to guard the Beaufort Inlet during 1808–9. The fort guarded the inlet during the War of 1812, but it was abandoned at the end of the conflict.

The U.S. government began construction on a chain of coastal forts, including the present Fort Macon, which protected Beaufort Inlet and Beaufort Harbor.

Construction began on the fort in 1826 and lasted eight years. Fort Macon was designed by Brigadier General Simon Bernard. It was named for North Carolina's eminent statesman Nathaniel Macon. Garrisoned in 1834, Fort Macon cost $463,790 to construct. In the 1840s, an erosion control system

was engineered by Robert E. Lee, who would later become a general in the Confederate army. At the beginning of the Civil War, North Carolina seized the fort from Union forces. In 1862, Fort Macon fell back into Union hands. It remained under Union control for the rest of the war.

Fort Macon was a federal prison from 1867 to 1876 and was garrisoned during the Spanish-American War. The government closed it in 1903, and in 1923, Congress offered up Fort Macon for sale. North Carolina bought the fort for one dollar, and it became the second state park. The fort was restored by the Civilian Conservation Corps in 1934 and 1935.

Fort Macon State Park opened to the public on May 1, 1936. It was used as a fort for the last time during World War II, from December 1941 to November 1944.

Fort Macon is a perfectly restored Civil War–era fort. It has a museum, a coastal education center, an unspoiled shoreline for fishing, swimming and beachcombing and undisturbed natural beauty. There are cannon and musket demonstrations and guided tours. It has many exhibits indoors and out and a bathhouse. It has handicap-accessible beach areas.

The fort also has its resident ghosts. The ghosts of Civil War soldiers have been see, and visitors have reported hearing strange disembodied voices. The ghosts of Confederate soldiers have been reported watching from the top of the fort. Strange sounds have been heard along the corridors. Shadowy figures and unexplained footsteps have been seen and heard.

Black Pelican Restaurant

The Black Pelican Restaurant was formerly known as Life-Saving Station 6. It was one of seven built on the Outer Banks.

In 1884, Captain James Hobbs was the keeper of Life-Saving Station 6. He had a crew of surfmen who were responsible for saving the lives of mariners in distress in the area known as the Graveyard of the Atlantic.

On July 7, 1884, Lieutenant E.C. Clayton arrived at the station. He was in charge of investigating charges by T.L. Daniels that James Hobbs was using government paint for personal use. One source says that Daniels was not one of the surfmen but wanted Captain Hobbs's job. Another source says that Daniels was one of the surfmen but didn't like taking orders.

On one occasion, Daniels offended Hobbs's wife so badly that Hobbs pulled his pistol and shot Daniels. The incident happened in front of the lifesaving station crew. The surfmen cleaned up the mess and took Daniels's body out in one of the boats and gave him a burial at sea. Without witnesses and a body, Captain Hobbs was never tried.

In 1993, the old lifesaving station and later additions became the Black Pelican Restaurant. Some employees believe the spirit of young Daniels is still there. One of the hostesses saw an apparition in the corner of the dining room. Staff and customers have heard footsteps while no one was there, and they also have heard doors closing. A child once saw blood running down the wall while seated at a table. When the staff arrived at the child's table, they could not find anything. A boy said he saw a ghost in the bathroom.

When you're on the Outer Banks, stop in at the Black Pelican Restaurant for a meal.

Albemarle Opera House

The Albemarle Opera House was built in 1908 by Locke Anderson Moody for F.E. Starnes Sr. and J.C. and D.F. Parker.

May 21, 1908, was the official opening show at the opera house. Polk Miller and his Old South Quartet, the Wake Forest Quartet, the Bernard Orchestra and Dekoven Male Quartet made appearances there.

The opera house hosted many plays, including *Tempest and Sunshine, Enchanted Woods, St. Elmo* and *Servant of the House. The Clansman,* with the original cast from the New York production by Thomas Dixon Jr., appeared at the opera house.

The introduction of motion pictures brought Jethro Almond's movie about Albemarle to the opera house. In 1916, the Alameda Theatre's opening meant the old opera house had to find other uses.

It became a storage building for coffins from 1918 to 1929 during the flu epidemic. In 1930, it became a VFW 2908 meeting hall. In the late 1930s and early 1940s, the Tarheel Club Orchestra used it for a dance hall.

Later, it became New York Dry Goods, owned by Adam N. Dry. That was followed by Bell Shoe Store. Then came Merit Shoe Store from the mid-1930s to 1970.

Optometrists F.E. Starnes Sr. and Cecil Duckworth treated patients in the offices. U.S. Commissioner Lula Shaver once occupied the offices as well.

In the 1930s, Ruth and Geraldine Peeler ran the Baltimore Beauty Shop, which later turned into Margaret's and then the Modern Beauty Shop. The last half of the twentieth century, the opera house was used as a storage facility for Starnes Jewelers and the City of Albemarle.

There have been rumors of ghostly goings on in the old Albemarle Opera House. Footsteps have been heard around the venue particularly on the stairway to the balcony. Shadowy figures have been seen. A band has been heard playing ragtime music in the fall, and a gray figure was seen in the balcony.

The National Register of Historic Places presented the owners with a plaque on its 100th birthday in 2007.

The Hammock House

The Hammock House was built between 1700 and 1709. Another source says it was built in the late eighteenth century or early nineteenth century. It is located on Hammock Lane in Beaufort, Carteret County, North Carolina. The Hammock House is the oldest house in Beaufort, which was established in 1709 and is known as the third-oldest town in North Carolina.

When the Hammock House was built, it was so close to Taylors Creek that you could tie a small boat up to the front porch. Over the years, Taylors Creek has receded, and now the Hammock House is on the third row of houses back from the creek.

Some very important people from Beaufort lived in the Hammock House in the early 1700s. These included Robert Turner, who plotted out the town of Beaufort, and Nathanial Taylor, who donated the Old Burying Ground to Beaufort. The house was known as the Taylor House when Nathanial Taylor owned it in 1719.

There has been some speculation that in the early days the Hammock House was used as an inn, serving as a resting place for weary travelers passing in and out of Beaufort. In the early days of the inn, according to legend, Edward Tech, also known as Blackbeard, visited the inn.

One legend says Blackbeard brought his wife to stay with him at the Hammock House. When Blackbeard left to return to the sea, he hanged her from one of the oak trees in the Hammock House front yard. Her lifeless body was buried beneath the tree. Many people still believe that

her ghost remains at the Hammock House and her screams can still be heard.

Another legend says that Blackbeard saw a member of his crew dancing with his girlfriend and beheaded him on the stairs. After two hundred years, the stains are still visible, even though the stairs have been sanded and painted.

In the latter half of the eighteenth century, Beaufort was a busy commercial port. Among the captains who commanded the sailing ships was Captain Madison Brothers. As Captain Brothers grew older, he decided it was time for him to get married. Even though Brothers had a bad temper, he finally found someone who would marry him, Samantha Ashley. Brothers arranged for Samantha to travel to Beaufort and stay at the Hammock House until his return. Upon his arrival in Beaufort, they would get married. She arrived only to find a British navy ship docked. Her brother, Lieutenant Carruthers Ashley, was on board. Samantha and Carruthers spent the next few days together.

The night before Lieutenant Ashley's ship was to set sail, a party was arranged at the Hammock House as a send-off for Samantha's brother. Just as the party was getting started, Brothers's ship sailed into port. Anxious to see his intended, he and a small group of men rowed up Taylor Creek to the Hammock House. The first thing Brothers saw was Samantha dancing with a young sailor. Jerking Samantha from the young sailor's arms, Brothers drew his sword and began attacking the sailor. Ashley drew his sword in defense. As the fight continued, Brothers drove Ashley up the stairs. Ashley tripped, and Brothers drew his knife and stabbed him to death. Samantha rushed to her brother. Brothers gathered his men and returned to the ship. He left Beaufort not knowing the truth.

Lieutenant Ashley's last request was to be buried in full dress standing at attention and facing England. In Beaufort's Old Burying Ground Cemetery, there is a British officer buried upright. It is said that the blood stains on the stairs where Ashley was killed can still be seen.

People have reported hearing the disembodied screams of a woman in the Hammock House.

During the Civil War, three Union soldiers disappeared heading up to the Hammock House. They were never seen again. The skeletons of three people were discovered in 1915 when workmen digging near the back porch unearthed them. Belt buckles and buttons were found with the skeletons. No one knows who killed the three Union officers or how they died. The spirits of the three Union soldiers still haunt the Hammock House.

A man named Richard Russell Jr. arrived at the Hammock House in 1747, and he took a slave into the attic to punish him. The slave pushed Russell down the stairs, killing him. His spirit is said to haunt the Hammock House also.

Visitors have reported seeing strange balls of light. Other people believe Blackbeard's ghost haunts the Hammock House. Some visitors have reported seeing apparitions.

After three hundred years, no one knows who built the Hammock House or when it was built or for what reason. There are still some original furnishings in the house. One of the lower-level rooms still has the original flooring and ceiling beams. The kitchen area has many original beams bearing stamps from the 1700s. The stairs have been renovated.

The two-story house has eight bedrooms, a huge covered porch, two fireplaces and dormer eyes—so people can see from the rooftop—that protrude from the roof.

The Hammock House is a private residence, so don't trespass.

Theodosia Burr Alston

Theodosia Burr was born on June 21, 1783, in Albany, New York, to Aaron Burr Jr. and Theodosia Bartow Prevost. Her grandparents were Aaron Burr Sr. and Ester Edwards Burr. Her great-grandfather was Jonathan Edwards.

Aaron Burr Jr. was born February 6, 1756, in Newark, New Jersey, and he was elected to the Senate in 1791. In 1800, he ran unsuccessfully for the presidency. He was elected vice president instead. In 1782, Burr become a licensed attorney, and in 1789, he was appointed attorney general of New York.

Theodosia grew up mostly in New York City. She studied French, music, dancing, arithmetic, Latin, Greek and English composition.

Theodosia Bartow Burr died in 1794, when her daughter was eleven years old. After this tragic event, her father supervised Theodosia's education. At age fourteen, Theodosia began to serve as hostess at Richmond Hill, Aaron Burr's stately home.

On February 2 or 12, 1801, Theodosia married Joseph Alston in Albany, New York, at the same church she was christened. Alston was the son of a wealthy South Carolina family. The newly married couple honeymooned in Niagara Falls, the first recorded couple to honeymoon there. They were further blessed in 1802 with the birth of their son, Aaron Burr Alston. The birth of her son took a heavy toll on Theodosia's health. She traveled to Saratoga Springs and Ballston Spa in an attempt to regain her strength.

Theodosia was having a hard time adjusting to the isolated life of a plantation mistress at the Oaks, the family estate on the Waccamaw River in South Carolina.

Joseph Alston was born on January 1, 1779, in All Saints Parish, South Carolina. He was privately tutored and attended Princeton University to study law. He served in the South Carolina House of Representatives from 1802 to 1803 then again from 1805 to 1812. Joseph Alston was elected the forty-fourth governor of South Carolina on December 10, 1812. He remained governor until 1814 and passed away on September 19, 1816.

In 1804, Burr blamed Alexander Hamilton for besmirching his name when campaigning for the governorship of New York, which Burr lost. A challenge was issued; Hamilton accepted, and the duel took place on July 11, 1804, in Weehawken, New Jersey. Hamilton lost.

During her father's trial, Theodosia traveled to New York to be by his side. He was acquitted of murder.

In 1807, Burr was charged with conspiracy. Theodosia once again stood by her father's side. He won an acquittal and left for Europe.

Theodosia returned to South Carolina, but her health was becoming more fragile.

In 1812, her ten-year-old son died of malaria in Charleston, South Carolina. Returning from Europe, Aaron Burr convinced Theodosia to come to New York for the holidays. Joseph Alston couldn't leave South Carolina to accompany his wife to New York and felt very uneasy about Theodosia's upcoming voyage. Theodosia's health continued to deteriorate.

The United States was at war with Great Britain, and there were rumors of pirates along the North Carolina coast. Granting Theodosia's request, Alston wrote a letter to the British navy blockading the coast, asking for safe passage for the wife.

Her father sent a trusted doctor, Timothy Green, to make the voyage with Theodosia. On December 30, 1812, Theodosia, Dr. Green and a maid boarded the schooner *Patriot*, which was moored in Charleston Harbor. Another source says Georgetown Harbor. The schooner sailed out of one of the ports, headed for New York City with Captain Overstock in command. Theodosia was now on her way to see her father, who had been in Europe for the past four years. The trip usually took five to six days, yet eighteen days passed with no word from Theodosia.

Twenty-nine-year-old Theodosia Burr Alston had vanished along with the crew and all passengers on board. The schooner *Patriot* was believed to be off

the coast of North Carolina when it vanished. After weeks of searching, no sign of the passengers, crew or schooner was ever found. Joseph Alston died in 1816 without ever knowing what happened to his beloved Theodosia.

SOME THEORIES

Word from Bermuda and Nassau was that a severe storm was coming up on the schooner's route. The crew was too experienced to get caught by a storm, so some believe the storm destroyed the schooner.

Others speculate that pirates captured the schooner, killed the passengers and crew and took their treasure. In 1833, a dying pirate in Alabama confessed that he helped rob the *Patriot* and murdered all on board in 1813. In 1848, a pirate dying in Michigan confessed to the same story. Theodosia was made to walk the plank. When she asked for a few minutes, the pirates granted them. Supposedly, she returned to her berth, changed into pure-white clothes, and with her Bible in hand, she returned and said that she was ready. Theodosia was calm, not a tremor or tear as she walked out on the plank. At the end, she folded her arms over her chest with her Bible, looked toward heaven and took her final step.

In 1869, when a doctor was called to treat an elderly woman on Hatteras Island, he noticed a portrait of a beautiful woman in her home. The woman told the doctor that more than fifty years ago, a looter took the portrait from a ship that had been abandoned and gave it to her. The portrait was believed to that of Theodosia. The lady, Polly Mann, gave Dr. William Pool the portrait instead of money. Over the years, he tried to get it authenticated by the Burr and Alston families. Their opinions varied greatly. The Nags Head portrait now hangs in the Lewis Walpole Library at Yale.

Some believed the schooner wrecked and Theodosia survived but had amnesia and was taken in by a family on Hatteras Island.

Another theory is the schooner *Patriot* fell victim to some military action during the War of 1812.

In 1910, a man told a story that had been passed down in his family about a body washing ashore in Carolina in early 1813.

A locket was found in the possession of a Karankawa Indian chief engraved with the name Theodosia. It was given to him by a young woman before she died.

The disappearance of Theodosia Burr Alston will forever remain a mystery in the history of the Carolinas.

Her ghost is said to haunt her plantation, the Oaks, in South Carolina and the Outer Banks, Richmond Hill and Bald Head Island, North Carolina.

Haunted Whalehead

The Whalehead, originally known as Corolla Island, was built in 1922 by wealthy industrialist Edward Collings Knight Jr. for his wife, Marie Louise Lebel Bonat, to serve as their winter home. He built it on Currituck Sound, Corolla, Outer Banks, North Carolina.

It was a splendid twenty-one-thousand-square-foot, five-story, Art Nouveau house with sweeping grounds. It was the biggest and grandest home on the island.

The Knights were the first residents to have electricity and running water on the northern portion of the island. They used a diesel motor for electricity and a two-thousand-gallon pumping system that provided them with amenities almost forty years before electricity came to the rest of the island.

Strangely enough, in October 1933, the Knights visited their home like they did every year. After three weeks, they moved out never and returned.

The Knights passed away in 1936. After their death, the estate served as a World War II Coast Guard receiving station, a secret research center for a company trying to develop solid rocket fuel and a host of other things.

In 1922, Corolla was a much different place than it is today. There were only a few residents and, of course, the employees of the Coast Guard station and the Currituck Beach Lighthouse. They had a one-room schoolhouse, a post office and a few other stores scattered about. There were no paved roads, and electricity didn't arrive until 1955.

There is more to Whalehead than stunning grounds and décor. The structure has eighteen-inch-thick walls, five chimneys and a copper-shingled roof. It has elegant woodwork and original signed and numbered Tiffany lighting, corduroy walls and cork flooring.

The Outer Banks is wildly known for its colorful history, turmoil and tragedy. The troubled history goes back to the early 1700s. The history of the Outer Banks is full of pirates, deadly storms, rough seas, shipwrecks and let's not leave out the Lost Colony of Roanoke. Now you can understand where the nickname Graveyard of the Atlantic comes from.

In 1992, Currituck County purchased the Whalehead property and secured a public sound access. By 1994, Currituck County had acquired thirty-nine acres that included the lighthouse and acres of waterfront property. Restoration began on the property in 1999 and was completed by 2002.

Whalehead is listed in the National Register of Historic Places. It is open to the public for self-guided tours, or visitors can take a tour with one of the site's knowledgeable guides.

Is Whalehead haunted? Some seem to think it is. People have reported tales of smoking paintings, self-igniting candles and a murder in the kitchen. There have been no murders or horrific deaths at Whalehead. Visitors have reported smelling cigar smoke in the room where the portrait of Edward Collings Knight Jr. hangs.

Marie Louise Knight's bedroom has gained a bit of a reputation as a spectral hotspot. When a couple was staying in Marie Louise's bedroom one night, the man got up to secure a slamming door. When he was returning to bed, he passed by a woman kneeling at the door; thinking it was his wife helping to secure the door, he headed to bed. He was surprised to find his wife in bed asleep.

Over the years, reports of disembodied voices have been heard coming from empty rooms. Pots and pans clanging in an empty kitchen and doors closing on their own have been heard. A policeman was on the second floor alone when he felt something grab his leg. A spirit of a little girl ran a boy out of the house, but no one else has seen the little girl. Many people feel an energy in the house that makes them feel uncomfortable.

If you're in the neighborhood, stop by for a visit.

Pioneer Theatre

In 1918, George W. Creef opened the Pioneer Theatre in Manteo, North Carolina. It remained in its original spot for nineteen years. In 1937, the theater moved to its present location and was owned and operated by George W. Creef's son Herbert Creef Sr. The Pioneer Theatre has been operated by the Creef family since it opened in 1918. It is now operated by H.A. Creef Jr. with the help of his son Herbert Creef III. It is the oldest family-run theater in the country. The Pioneer Theatre is a landmark structure on Roanoke Island.

Cellphone use inside the theater is strictly prohibited, and no R-rated movies are shown there. It represents a nostalgia and a sense of family atmosphere that can't be replicated anywhere else. It's a single-screen theater of days past.

Some locals believe the Pioneer Theatre is haunted by a past family member who is still watching over the place.

Rum Keg Girl

The Old Burying Grounds in Beaufort, North Carolina, is an old cemetery. The earliest marked grave is 1711. In the back of the Old Burying Grounds, a wooden plank about the size of a checkerboard marks an unidentified person's grave. The strange story involves a young girl who had a very unusual burial. The hauntingly beautiful Old Burying Grounds stands out from the rest. It's home to a little girl buried in a rum keg.

The grave site is covered with beads, toys, coins, stuffed animals, dolls and many other items of affection. The wooden grave marker has no name, no birthdate, no date of death or scripture from the Bible. The only words carved across the front of the grave marker are "Little Girl Buried in a Keg of Rum." They believe it's the Sloo child.

The story begins in the mid-eighteenth century with a family named Sloo (pronounced Slow). The child emigrated from England with her parents, Merchant Captain Sloo and his wife. The Sloo family was very prosperous and built a beautiful home on Beaufort's waterfront.

After years of pleading by Captain Sloo's young daughter, her mother finally agreed to let him take her with him when he traveled back to England. The mother did not take this voyage but made her husband promise to bring her daughter back to Beaufort. The young girl finally got to see the land where she was born. It was an exciting trip for her.

On the return trip the little girl fell ill. There was nothing her father could do for her. She died aboard the ship still weeks from Beaufort. It

was the custom in those days when someone died on board a ship they be buried at sea. The captain couldn't stand burying his little girl at sea, as he had promised to return her to her mother. He had one other choice left. The ship carried a supply of rum. He bought a keg of rum, placed her body in it to preserve it and sealed the keg shut. Captain Sloo returned home with the heartbreaking news for his wife. They arranged for their daughter to be buried in the Old Burying Grounds cemetery with the rum keg as her coffin.

Today the grave of the Rum Keg Girl is one of the most beloved graves in North Carolina. It draws thousands of visitors to Beaufort's Old Burying Grounds cemetery every year. She is not buried in the family plot for whatever reason.

Some say the figure of a small girl can be seen running and playing between the graves at night in the Old Burying Grounds. Some say the toys on her grave are often moved around.

In June 2016, a nineteen-year-old Morehead City teenager damaged the grave by setting the wooden marker on fire. When the fire department responded to the cemetery, the grave marker was still slightly ablaze.

The police charged the teenager with felony desecration of a grave, indecent exposure (he was relieving himself on the grave) and trespassing. About $3,500 worth of damage was done to the historic grave site.

45

The Death House

In Pasquotank County, near the coast of Albemarle Sound, stands an old abandoned house rumored to be haunted and cursed, known as the Death House. It is considered one of the most haunted houses in the county.

The house was built by Thomas Lynch Shannonhouse and his wife in 1816. Their son John took over the house when Thomas and his wife passed away. John surprised his daughter Ellanora with a horse for her sixteenth birthday. It was a wonderful birthday for Ellanora. She rode the horse just about every day. One day the horse threw her. She hit the ground hard and was seriously injured. John and his wife did everything they could, but after two days she died on September 7, 1866.

John was grieving over the loss of his daughter and screamed out this curse: "I hope all who live in this house shall feel the pain of death that I am feeling now."

John sold the house to a man named Stanton. Soon after he and his family moved in, two of his children caught diphtheria and died.

The house was then sold to a farmer named Lister. Shortly after moving in, three of Lister's children caught diphtheria and died.

The people who bought the house after Lister's children died claimed that there was a ghost in the house. A farmhand who died of tuberculosis claimed that before he died he saw a young girl dressed in white riding a horse down the road.

In 1923, after the Markham family moved in, Mrs. Markham was sitting on the front porch and saw a young girl dressed in white riding a horse down the road. She greeted the young girl, but the girl did not return her greeting. Mrs. Markham started toward her, but the girl vanished. The next day, Mrs. Markham's baby became sick and died shortly thereafter. In the 1930s, the Markham family moved out. The curse took its last victim in 1969.

The house was abandoned in the early 1970s. Now it stands in a state of ruin. True story or campfire tale?

Somerset Place

or hundreds of years, the land south of Albemarle Sound was mostly swampland. The 200,000 acres were home to many woodland creatures, including bears, panthers and rattlesnakes. It would later become known as "The Great Eastern Dismal." However, it did have a good stand of juniper, maple and gum trees.

In 1729, the colonial government formed a new county, Tyrrell County, taking land from Chowan, Bertie, Currituck and Pasquotank Counties. Tyrrell County was named after one of the Lords Proprietors of the colony, Sir John Tyrrell. In 1799, part of the western part of Tyrrell County was used to create Washington County.

In 1755, a group of local men ventured into the swamp looking for land that could be used for farming. A man named Benjamin Tarkinton climbed a tree to see what he could see from higher up, and he spotted a lake. Josiah Phelps ran to the lake and claimed the right to name it after himself, Lake Phelps. The lake covered sixteen thousand acres, but without resources to build a road or a canal for transportation, development would have to wait for another thirty years.

In 1784, a group of men from Halifax and Edenton received authorization to drain the lake and farm the bottom of the lake. The lake was on higher ground than the Scuppernong River some six miles away. Businessmen Nathaniel Allen and Samuel Dickerson took Josiah Collins into a partnership known as the Lake Company. They acquired 100,000 acres of land in the area. Collins already had 60,000 acres on the Alligator River.

The Lake Company had a verbal agreement in 1784 for acquiring land near the lake and digging a canal from the lake to the Scuppernong River for transportation and drainage. The canal was finished in 1788. It was six miles straight, with a width of twenty feet and four to six feet deep. When the canal was finished, the company built a road on its bank. People could now traverse the area by boat or horse and wagon, turning the shore of Lake Phelps into productive farmland. The company hired Thomas Trotter, a Scotsman, to be in charge of the drainage and irrigation. A sluiceway and a millrace were built to use water to turn waterwheels, and a sawmill and a gristmill were added. Barns and other buildings were built as needed. Rice and wheat became important crops, and lumber was another important resource.

By 1816, Collins and his sons had acquired all of the 100,000 acres of land. Josiah Collins was eventually able to convert it all into a single private estate. Collins did not establish permanent residence at the lake until about 1830. He would call it Somerset Place.

At Josiah Collins's death in 1819, he left a life estate to his son Josiah Jr. At the time of his son's death, the property was to be divided among the seven grandchildren; the eldest, Josiah Collins III, would get Somerset Place. In January 1830, Josiah Collins III arrived at Somerset Place with his bride, Mary Riggs, of Newark, New Jersey. Shortly after Josiah III's arrival, he began enlarging and furnishing the house known today as the Collins Mansion. Christmas brought a special time of celebration, with family and friends dancing and singing for several days.

For the wedding of his son Josiah IV in 1859, the entire house was redecorated. The cake was brought in from New York. It was a festive occasion.

As the years passed, corn replaced rice as the principal crop. In 1860, the farm was producing about thirty thousand bushels of corn.

After the onset of the Civil War in 1861, three of the Collinses fought for the South. In mid-1862, the Collins family fled to Hillsborough. In 1863, Josiah Collins III died a refugee. The plantation had been plundered by Union troops and by the locals. Farming stopped, and the plantation fell into a state of decay. Two Collins sons and their mother returned to Somerset Place in 1865, but they were unable to revive the estate. In 1867, the Collins family auctioned off the entire plantation to satisfy their creditors. The property changed hands, and a bank in Rocky Mount, North Carolina, got control of it in the 1920s.

In 1937, the Federal Farm Security Administration acquired Somerset Place and divided the land into single-family farms for sale. Long-

needed roads were put in; however, some destroyed historic remains near Somerset Place.

In 1939, the State of North Carolina obtained a ninety-nine-year lease on the Collins Mansion and adjoining land and buildings, creating Pettigrew State Park. The park was named after James Johnston Pettigrew, a Confederate general. In 1947, the State of North Carolina signed a quitclaim deed for about 203 acres, permanently establishing the park.

In 1967, the North Carolina Division of Parks and Recreation transferred the mansion and outbuildings to the North Carolina Department of Cultural Resources, Office of the Archives and History, Division of State Historic Sites and Properties. The park is located in Washington County, North Carolina.

The Somerset Plantation house and gardens are said to be haunted by the former owner's wife. Rumor says that she screams and cries, mourning the death of her son.

Phantom Harpist

One of the most benign spirits in North Carolina is the spirit of Antonio Caselleta at the Brunswick Inn in Southport.

Antonio Caselleta was born in Italy in 1860. He emigrated from Italy to New York in the late 1800s, and in the summer of 1882, Caselleta, his wife and their young child relocated to Wilmington, North Carolina. He was in search of work as a musician.

Shortly thereafter, Caselleta was offered a job playing the harp in the Brunswick Inn in Southport. Caselleta and his family stayed there.

The Brunswick Inn was built around 1859. It flourished in its prime with weekend balls and dances in the 1880s. Locals and visitors alike would turn out for a few days of music and dancing.

On the evening of August 23, 1882, Caselleta went sailing with some fellow musicians between Bald Head Island and Battery Island. He kissed his wife and child goodbye at the dock at Wilmington, not knowing that this would be the last time he'd see them. He waved from the deck of the *Passport* and sailed straight into a North Carolina legend.

There are different accounts of what happen to cause the boating accident and Caselleta's death. He drowned near Battery Island across from Southport, North Carolina.

One account is that Caselleta was on his way to work when his boat sank. He was the only casualty. Another account states he went sailing one night with other musicians from the hotel, fell overboard and drowned.

His body was recovered and buried at Old Smithville Burying Ground. He remains there to this day. The cemetery is a typical southern cemetery with trees and a lot of Spanish moss.

According to local lore, the band decided to play on the night of his death without him. They left his chair empty and his harp beside the chair in his honor. To everyone's surprise, when the band started to play, harp music joined in.

Another account said the ball was canceled out of respect for Antonio Caselleta.

In the middle of the night, guests at the Brunswick Inn said they were awakened by the beautiful sounds of the harp echoing throughout the halls still enchanting its listeners from the beyond.

Some say the harp was found the next morning with all the strings broken. People who have stayed at the Brunswick Inn say the spirit of Caselleta remains in the inn to this day. He frequently makes appearances and makes himself known by the sound of the harp.

Mary, the owner of the Brunswick Inn, says the sound of the harp sounds like its coming from a great distance. Mary and her family have owned the Brunswick Inn since 1949.

Antonio is also helpful around the inn. He has a habit of closing the windows during a storm before anyone else can get to them.

Could it be that Caselleta will be around to play the harp throughout eternity? His stone monument can still be seen in the Old Smithville Burying Ground in Southport.

III.

Other Mysteries along the Coast

JUST A THOUGHT

Did the devil once take up residence in North Carolina or just drop in for a visit? Why did Native Americans and early explorers give the names that they did to certain locations? Why were so many locations linked to the devil? Does the devil have a favorite place, or does he just pick a place and drop in for a visit? Are the names to these places just coincidence? Let's examine a few of the locations and legends around coastal North Carolina named after the devil himself.

Bath Hoof Prints,
aka The Devil's Hoof Prints

There are a number of dates associated with this story—August 1802, 1813, early 1800s and 1850. All sources seem to agree it was on a Sunday, so we'll let the different years go for now. There were two different names given: Bath Hoof Prints and the Devil's Hoof Prints.

The event that made this story a legend is a horse race between Jesse Elliott, a horse racer with a bad reputation, and the devil. Elliott was well known for being a drunkard, a brawler, a gambler and apparently anything that was sinful, just an all-around nasty man.

Jesse Elliott owned a black stallion named Fury that he thought could outrun any other horse. Elliott would take on any challenge anytime.

On a quiet Sunday morning in August sometime in the early 1800s, a stranger dressed in black and riding a solid black horse approached Elliott. The stranger challenged him to a horse race. Elliott quickly accepted his challenge and rushed home to prepare for the race. When he met the stranger at the course, it was about church time.

Elliott and the stranger made a wager of $100. Some say that Elliott made a deal with the devil to help his horse win the race.

Several sources say that Elliott's wife was tired of his Sunday racing, and as he left the house, she shouted at him, "I hope you're taken to hell this very day!"

When Elliott arrived at the course, he noticed the stranger was already there. He noticed there was something strange about the man in black, something demonic. The stranger had an evil look in his eyes that burned

something horrible. Elliott was frightened by what he saw, but his greed outweighed his fears.

Elliott and the stranger lined up. As the race began, Elliott's horse dashed ahead. Since the stranger was lagging behind, Elliott, with all his conceited confidence, knew that he was going to win. Elliott shouted at his horse, "Take me in as a winner or take me to hell!" As soon as the words came out of his mouth the stranger rode up beside him. At that moment, Elliott's horse dug its feet deep into the ground, throwing him head first into a pine tree and killing him instantly.

The stranger rode up to Elliott's body, stooped over it and got back on his horse. In a flash, the stranger and his horse disappeared. Did the devil ride back to hell with Elliott's soul?

Old-timers believe that the man dressed in black was the devil coming to claim Elliott's soul. Some say that Elliott's horse disappeared into the woods, never to be seen again. Clumps of Elliott's hair remained stuck to the pine tree for years. The side of the tree that Elliott hit eventually died, and it has been cut down.

Only the hoof prints of Elliott's horse remain as a testimony to what happens when you make a deal with the devil. They are a constant reminder of Jesse Elliott and the race he lost with the devil. Tracks from the stranger's horse stopped in the road in front of the pine tree. No other tracks were ever found where the stranger's horse rode off.

The hoof prints are located at the edge of the forest. No vegetation will grow inside them, and no fallen pine needles or other woodland debris will remain in the hoof prints. People have placed objects in the hoof prints only to find them gone when they return.

In the 1950s a reporter put chicken feed in and around the hoof prints. The chickens ate the food from around the prints but didn't touch the food inside the prints.

Scientists have conducted studies on the dirt from within the hoof prints in an attempt to provide an explanation. Of course, no explanation has ever been given. Some of the more popular theories are vents for a subterranean water pocket or the results of salt veins. None of these or any other theory has been proven. So for now, the hoof prints are still as much a mystery as they were two hundred years ago.

The area containing the hoof prints is private property. There is no longer a path leading to the hoof prints. Do not trespass. Get permission before you go looking for the prints.

The Devil's Christmas Tree

Long before the area was known as North Carolina, this legend began at the location of what is now known as Lake Phelps in Tyrrell County.

It started on Christmas night with a man and a mistake for which he paid the price. A hermit lived on the lakeshore and was known as quite a strange man. The hermit lived off the land as much as he could, but he had to make an occasional trip to Colonel Thomas Henry's trading post to get the needed things that the land didn't supply him with.

Accompanied by his faithful dog, the hermit would venture out into the woods or across the lake in a canoe that he had made himself. They never came back empty-handed.

On a cold Christmas Eve, the hermit decided to go in search of fresh meat for supper. He got his faithful old dog and headed across the lake. When the hermit was about midway across, the weather took a turn for the worse. It became frighteningly bad, but the hermit and his dog pressed on.

As the hermit and his dog reached the other side of the lake, the weather worsened. It began to snow. The last thing the hermit needed was a snowstorm. He sent the dog out in search of food despite the falling snow. Not far into the woods, they came up on a deer, a completely white deer. The hermit fired at point-blank range. There was no way he could miss at that distance. The deer looked at the hermit and dashed off into the woods.

After more hunting, the hermit finally bagged the big one. Making his way back to the lake with his dog and their supper and still fighting the

increasingly bad weather, they finally reached the lake. After continuing to fight the relentless attack of the weather, they finally made it to the safety of their cabin.

The hermit rushed into the cabin, built a fire and returned for his deer. When he reached his canoe, the deer and his dog had vanished. There was no one around and no footprints except those of the hermit.

The only thing the hermit could find was a trail of blood leading off into the woods. Thinking someone had helped themselves to his supper, he started out after the culprit. After following the trail for some distance into the woods, he finally came to the end of the trail of blood—but no deer or dog. There in front of the hermit was a huge cypress tree covered in an eerie blue light. The spirits of the forest were dancing around the tree. When they saw the hermit, they shouted in unison, "He shot the white deer. The devil is going to get him." Sitting in the top of the tree looking down at him was the devil himself.

The hermit made a hasty retreat from the woods and headed toward Colonel Thomas Henry's Trading Post. When he reached the trading post, he rushed in, rambling on about the devil. With a little help from rum and a warm fire, the hermit finally fell asleep.

The following day, the hermit set out to find his lost dog, telling Henry that he'd be back and let him know what he'd found.

The old hermit never returned, so Henry went to his cabin to see if he was OK. The cabin was empty—no sign of the hermit. Henry found some footprints outside of the cabin and followed them to a huge cypress tree. There he found the hermit kneeling by the tree, frozen or perhaps scared to death. He had 666 burned into his forehead.

There is a lot of information left out of this story, and it's probably just a campfire tale.

50

The Devil's Last Supper

I n April 1810, a group of rich kids in Wilmington, North Carolina, filled their days with wild parties and Roman orgies. With an almost unlimited amount of money, they had plenty of time to party. The leader of the group was Lecter Daniels, a young man with a brilliant mind. Daniels left the University of North Carolina at Chapel Hill under less than favorable circumstances and had to move back home to Wilmington. He went to work in the family business.

In early April, Lecter Daniels noticed people preparing for the Easter holiday, and he got the idea of having his own last supper. He gathered a group of friends he thought would fill in nicely for the original participants at the last supper. Lecter would play Jesus.

The group rented the top floor of a brothel in Wilmington and kept their plans a secret from the madam for fear that she would not rent them the room.

When April 19 arrived, everything was complete. There were new linen tablecloths, candles and glowing chandeliers. The food was a feast for a king. It consisted of a pig, seafood and wild turkey. The alcohol, or as some referred to it, the devil's nectar, was in abundance. Kegs of rum and plenty of champagne were also available for the bacchanal.

By 10:00 p.m. all the guests were there, all drunk. As the hours passed, they continued to drink more and more alcohol. Lecter Daniels staggered to his feet, barely able to stand, still wearing a crown of woven smilax on his head; he raised his glass to propose a toast. His glass shattered, and

an expression of unimaginable horror came over him as his hand began to bleed.

The room became dead silent. Lecter spoke, but not in his own voice. It was the voice of evil. He pronounced each word with complete clarity, "Dead in six months." Lecter then repeated the same four words, "Dead in six months." Lecter Daniels then ran out of the room. The other guests remained silent; not a word was spoken as they left the room one by one.

A week later, a young man who had played Peter at the last supper was found dead in the river near his home. He had been a strong swimmer, and the boat was not overturned. In the weeks that followed, one by one, all of the guests of the last supper died under mysterious circumstances—except Daniels. Daniels signed on to a ship bound for sea. That was the last time anyone on land would see Daniels alive.

It was the Christmas season before the ship's cook came ashore and told the story. One night in late October, the ship was battling a severe storm. The crew was gathered together in the forecastle. Lecter Daniels told his shipmates the story of that dreadful night, and the evil voice came to him again: "Gentlemen, tonight it is exactly six months since Good Friday." Without any warning, Daniels got up, climbed the ladder, let out a horrible scream and threw himself into the ocean.

Kill Devil Hills

Many legends surround the name Kill Devil Hills, North Carolina. I'm going to touch on a few of them in this section.

One of the legends is that Kill Devil Hills got its name from the wreckers that scavenged shipwrecks transporting barrels of rum along the coast of the Outer Banks. The English referred to the rum as Kill Devil.

Another story is a ship wrecked opposite the hills and was loaded with Kill Devil Rum.

In the 1700s, William Byrd of Virginia, apparently no admirer of the Carolinas, said that most of the rum in this country was so bad and unwholesome that it is not improperly called Kill Devil.

The trade in rum expanded into the colonies in New England, and that is possibly when the name Kill Devil arrived in the Outer Banks, through shipwrecks loaded with Kill Devil Rum.

There were more than one thousand ships wrecked along the Outer Banks. The area became known as the Graveyard of the Atlantic. Many of the shipwrecks contained barrels of rum. It's possible that the town was named Kill Devil Hills for all the booze.

Another story was that the rum was strong enough to kill the devil. The name could have come from all the barrels of rum being hidden behind the hills.

Another story, though not as popular as the ones about Kill Devil Rum, is that at sunset you could see the silhouettes of foxes on the hill, giving the appearance of devil horns.

Another story to where it got its name is a local man tried to extort money from the devil and then trapped him in a deep pit on top of one of the many tall sand dunes that shape the town's rugged landscape.

Sailors say it's enough to kill the devil to navigate that part of the sound.

One of the most popular stories is about pirates. The legend goes that some pirates were sitting in the sand dunes getting inebriated on rum that was so strong that it would kill the devil.

In 1808, the first mention of Kill Devil Hills appears on maps, "killdevil Hills." An 1814 map gave the name as Kill Devil Hills as well.

Kill Devil Hills's history is hard to trace prior to the Wright brothers' first flight in 1903.

In 1953, the town of Kill Devil Hills on the Outer Banks in Dare County was officially incorporated. Kill Devil Hills includes more than six thousand residents. It has shops, restaurants, hotels and the Wright Brothers National Monument, where the first flight occurred.

In the 1700 and 1800s Kill Devil Hills was inhabited by a small group of local farmers and fishermen. In 1878, the Kill Devil Hills lifesaving station was established across from the current Wright Brothers Monument. In 1900, the Ohio-based Wright brothers, Orville and Wilbur, chose Kitty Hawk and Kill Devil Hills as the location to test their new flying machines. Their first manned glider flight from the tall sound side dunes was unsuccessful. On December 17, 1903, the Wright brothers made the first controlled and sustained power flight. In 1911, Orville Wright returned to Kill Devil Hills and set a new world glider record, total air time nine minutes and forty-five seconds. The glider earned the title of the last flying machine at Kitty Hawk. In 1927, Calvin Coolidge signed a bill granting $50,000 for construction of the Wright Brothers Memorial. In 1930, a design was chosen, and an additional $150,000 was granted for construction. In 1932, the Wright Brothers Memorial opened to the public and was dedicated with Orville Wright in attendance. Orville was the first American to see a national memorial dedicated to him while still living.

The Great Dismal Swamp

The Great Dismal Swamp covers 112,000 acres along North Carolina's northern border with Virginia. In a quote from the Dismal Swamp Welcome Center, "The Great Dismal Swamp is a geological wonder. For millions of years before the swamp was found it was under the sea. It is viewed by naturalists and other scientists as one of the best outdoor laboratories in the world! This natural treasure emerged as a landform when the continental shelf made its last significant shift."

I could not find a record of who discovered the Great Dismal Swamp. In 1728, Colonel William Byrd II was a member of the commission that surveyed the North Carolina–Virginia state line, and he was the first to provide an extensive description of the Great Dismal Swamp.

George Washington made his first trip to the Great Dismal Swamp in 1763. Washington suggested draining the swamp and digging a north–south canal through the swamp to connect with the Chesapeake Bay in Virginia and Albemarle Sound in North Carolina. Washington formed a group and hoped to drain the swamp, harvest the trees and farm the land.

The company purchased forty thousand acres of swampland in 1763. By 1796, Washington had become disappointed in the management of the Dismal Swamp lumber business. Washington never sold his land holdings, and they passed on to his heirs at the time of his death in 1799.

Camp Manufacturing Company acquired all Dismal Swamp Land Company property in 1909. By the 1950s, at least twenty thousand acres of virgin timber had been removed. In 1973, Union Camp (Camp

Manufacturing was a predecessor of Union Camp) donated its Virginia swamp holdings to the Nature Conservancy, which in turn donated it to the Department of the Interior for the creation of the Great Dismal Swamp National Wildlife Refuge.

William Drummond discovered a three-thousand-acre natural lake in the heart of the swamp, and it still bears his name, Lake Drummond. Drummond was the first governor of North Carolina, 1663–67. The Great Dismal Swamp State Park features twenty miles of trails beyond a two-thousand-foot boardwalk that puts visitors in the midst of the Great Dismal Swamp.

The Great Dismal Swamp provides a creepy setting for ghostly hauntings and other strange goings-on. Visitors have reported seeing strange lights and ghosts and hearing unexplained noises in the swamp.

At night, when darkness creeps over the Great Dismal Swamp, tales of ghosts and other fiendish creatures don't seem too far away.

Many spooky legends come from sightings of the vapors that rise at night along the trails, fox fire and glowing fungi belched from swamp gasses that drift through the air. However, there are some things in the swamp that can't be explained.

One strange phenomenon that has yet to be explained is that compasses point unreliably in the Great Dismal Swamp. This phenomenon dates back to George Washington's time.

Some forty years ago, a park employee was driving down the Washington Ditch Trail when his dog began to bark violently. The park employee's headlights hit a young man and woman dressed in colonial-era clothes. The couple silently walked toward the employee. He stopped the truck to offer his help if needed. He greeted them, and they said nothing. The employee looked back to tell his dog to hush his barking, and when he turned back around, they were gone. He looked around but could not find any sign that the couple had been there.

A small community grew up there called Dismal Town. A man and woman in the community wanted to get married, and one day, the groom-to-be went into the woods to go fishing. When he didn't return, a search party was assembled and set out to find him. Darkness was creeping in, and the search party had not returned. The bride-to-be went into the swamp in search of her intended. The search party returned, but the young couple never did. The spirit of the lost couple is believed to haunt the Washington Ditch Trail.

Another legend says that a witch would change herself into a whitetail doe when a hunting party would come into the swamp and lead their dogs through the swamp.

Another story is about a hunter and his Indian guide. While hunting, they came upon the witch in human form. She changed into the doe and ran off into the swamp. The Indian guide directed the chase into a bog filled with briars and vines, trapping the witch, who quickly turned herself into a tree stump. The stump looked like a deer jumping.

The guide quickly called on the devil, which brought a powder. The guide and the devil sprinkled it around the stump. The guide chanted at the stump as lightning flashed and thunder roared, and the witch was never seen again. The stump remained there until a fire destroyed it.

53

The Boo Hag

The legend of the Boo Hag comes from the Gullah culture found in North and South Carolina. According to legend, the Boo Hag is similar to a vampire but gains its sustenance from a person's breath by riding its victim. The Boo Hag doesn't have skin, so it is blood red with blue veins. In order to go unnoticed, it steals a victim's skin and uses it as long as it holds out. It removes the skin before it rides someone.

When a suitable victim is found, the Boo Hag will go to his or her house at night and enter the house through an open window, door or any little crack or hole. It will search the house to find the room where the victim is sleeping. It positions itself over the sleeping person, sucking out his or her breath (much like a cat sucking out a baby's breath). This puts the victim in a dream-like state, rendering the person helpless. Victims who wake up before the Boo Hag finishes might find themselves skinless. After the Boo Hag finishes, it will fly out the house and return for its skin. It must be in its skin before dawn, or it will be trapped outside forever. The victim doesn't remember anything and feels a little tired.

There are several ways to keep a Boo Hag out of your house. Paint around windows, doors or any other place a Boo Hag can go through, or place a broom outside the door or by your bed—the Boo Hag will stop to count the straws.

Boo Hags are usually found along the North and South Carolina coast. "Don't let da hag ride ya" is a South Carolina phrase.

Outer Banks

*F*or centuries, people have been drawn to the Outer Banks. The English colonists were the first Europeans. On June 22, 1585, John White and a group of 116 colonists landed on Hatteras Island.

John White and the colonists didn't consider Hatteras Island an ideal location to found a colony, so they continued their journey and landed on Roanoke Island. This was a much better location.

White sailed back to England to get supplies to ensure the survival of the colony. When he arrived in England, he found England was at war with Spain and was held up for three years. When White returned to Roanoke Island with the supplies, the colonists had disappeared. The settlement had vanished without a trace, creating the greatest and America's oldest mystery—one that has yet to be solved.

After word of the lost colony, people lost interest in the Outer Banks. The inlets and coves and outlying islands became a haven for pirates. It was the perfect hiding place, with plenty of spots to hide their treasure. During the 1600s and early 1700s, the Outer Banks was a base for a lot of pirate activity. One of the most famous pirates was Blackbeard, who made Ocracoke Island his home. One day, the British Royal Navy caught up with Blackbeard, nearly ending piracy on the Outer Banks. Other pirates who frequented the Outer Banks were Calico Jack, Anne Bonney and Mary Reed.

The Outer Banks spans two hundred miles along the North Carolina coast. The string of barrier islands was accessible only by boat. As people started moving to the Outer Banks, they lived a simple life, mostly fishing.

Some salvaged shipwrecks and steered ships through the seaways of the Outer Banks.

The state constructed several lighthouses to help prevent shipwrecks, and several lifesaving stations were set up to help rescue shipwrecked victims. Lighthouses were instrumental in reducing the number of shipwrecks.

By the late nineteenth century, several changes to the Outer Banks were underway. The islands that were used during the Civil War were becoming summer retreats. The barrier islands began seeing more commercial fishing than recreational.

In 1902, Reginald A. Fessenden conducted experiments in wireless telegraphy. Fessenden demonstrated a successful transmission and reception: a 127-word message was sent from Cape Hatteras to Roanoke Island some forty-eight miles away. The historical marker is located at US 64/264 near William B. Umstead Bridge in Manteo, Dare County, North Carolina. It reads, "R.A. Fessenden Inventor Pioneer in Radio Communication Conducted Wireless Experiments 1901–02 From a Station 600 yards S.W."

In the 1960s, the New Deal highway provisions and the construction of the Herbert Bonner Bridge connected the Outer Banks to the mainland. Today, in addition to the bridge, a ferry transports people from the mainland to Ocracoke Island.

Known as the Graveyard of the Atlantic, the waters around the Outer Banks have claimed thousands of ships and an untold number of human lives. There are two thousand known ships entombed in the waters off the North Carolina coast.

A large portion of the Outer Banks has been designated as a national seashore. The Outer Banks are considered to be areas of Coastal Currituck County, Dare County and Hyde County.

When visiting the Outer Banks, you can visit a variety of shops and restaurants and enjoy the nightlife. There are historic sites, and visitors can enjoy the scenery of pristine maritime forests. There are top-rated golf courses for those wishing to play. There are museums, restored historic homes, lifesaving stations and lighthouses.

Archaeologists believe the Outer Banks were once inhabited by Native Americans. There were a number of tribes living there—the Kinnakeet, Ocracoke, Chicamacomico, Hatteras, Algonquins, Chowanog, Poteskeet and Croatan. Fighting with the new settlers and new diseases brought by the settlers wiped out most of the Native Americans.

Great Britain owns a small part of Ocracoke Island: the British cemetery on Ocracoke Island is officially located on British soil. The graveyard

contains the graves of British sailors laid to their eternal rest. Their bodies were recovered after the wreck of the HMS *Bedfordshire* during World War II. The HMS *Bedfordshire* started out as a privately owned commercial fishing boat, and when England entered the war, the boat became part of the Royal Navy. It was assigned the duties of patrolling the coastline of the mid-Atlantic states.

On the morning of May 14, 1942, two bodies washed up on the shore of Ocracoke Island. They were identified as being from the HMS *Bedfordshire*. Later, more bodies from the HMS *Bedfordshire* were found on the shore of Ocracoke. The bodies of the sailors were buried in a quiet corner of the graveyard in Ocracoke Village. The local citizens took care of the graveyard.

A lease for the tiny plot where the British sailors were laid to rest was given to the Commonwealth War Graves Commission for as long as it remains a graveyard. The graveyard officially became a British cemetery. The British flag flies over the graves of the sailors from the HMS *Bedfordshire*, and the U.S. Coast Guard station on Ocracoke Island maintains the graves.

Every year on the Thursday and Friday closest to May 11, British and American citizens meet on British soil to honor the fallen heroes.

Odd Sea Creature Visits Outer Banks

For several days, the northern beaches were invaded by millions of odd sea creatures. The gooey little organisms washed up on the beach with the waves. They were about an inch long, with clear bodies and orange organs. The creatures had wing-like appendages.

These animals are typically found in the waters of the North Atlantic. Changes in the wind direction sometimes cause colder water to rise up and wash on the beaches. These tiny little creatures just come ashore with the colder water.

They are not harmful. Once they wash up on the shore they die, according to marine specialist Terri Hathaway.

The creatures are pelagic sea slugs, also known as sea angels or the common clione.

They do not represent any danger to beachgoers.

The Gray Man of Hatteras

*F*or some strange reason, most people associate the fall season with ghosts. Whether the weather has a connection to paranormal activity has never been proven, at least scientifically. Maybe it's the fact that Halloween is just around the corner and everybody associates Halloween with ghosts.

The people on the North Carolina coast, Cape Hatteras to be exact, don't need scientific methods to prove there's a ghost, just a hurricane. And the fall season certainly brings hurricanes. The romantic coastlines of the Outer Banks are well known for ghost stories. The haunted lighthouses, pirates, old graveyards, thousands of shipwrecks and the seafaring people who were untimely plucked from this earth to meet their maker all conjure up ghostly apparitions.

Cape Hatteras is an unspoiled area of natural beauty with windswept dunes, the crashing surf and a seventy-mile-long pristine beach. It's paradise for the beach lover. One source says that North Carolina is fourth on the list of states hit by Category 4 hurricanes. Cape Hatteras sits on the edge of the Gulf Stream, a massive flow of warm water that circles through the Atlantic Ocean. If a hurricane comes near the North Carolina coast, there's a real good chance it's going to hit Cape Hatteras.

Cape Hatteras is known for something other than getting hit by hurricanes. It's also known for the Gray Man of Hatteras. The islanders know that when a storm is coming, the Gray Man appears. The Gray Man is an indistinct shadowy figure of a man dressed in gray that appears on

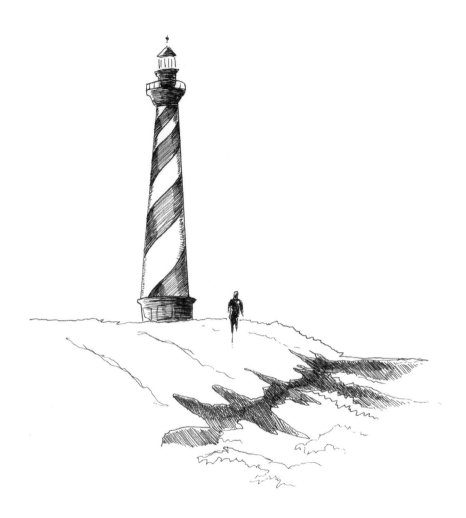

the beach when the first winds come from the approaching hurricane. No one has ever heard him speak or been able to approach him. If someone gets too close, he slowly fades away. The Gray Man has been appearing on the island for over a century. He appears out of nowhere, and when his job is over, he just fades away into the wind and rain. His first appearance was in the early 1900s. He is mostly reported to be seen in the vicinity of the Cape Hatteras Lighthouse and is usually seen walking between Cape Hatteras Lighthouse and Cape Point.

Who the Gray Man is has never been proven. Some believe that it's not a ghost at all but an expression of the force behind the hurricane as it moves in on the island.

Some say it's the ghost of a sailor who was killed in a hurricane coming back to warn the islanders of the impending danger of an approaching storm.

Some say it's a man named Gray who lived near Cape Point in the late 1800s.

All agree on one thing. If you happen to have an encounter with the Gray Man, heed his warning and get off the island in a hurry.

Graveyard of the Atlantic

The June 1585 wreck of the *Tyger*, an English ship belonging to the expedition of Sir Richard Grenville, is the first recorded ship to be lost in what would become known as the Graveyard of the Atlantic. However, another source says record keeping of shipwrecks began in 1526. Since then, more than five thousand ships have sunk in the waters off the North Carolina coast, including the infamous Cape Point, which today is a popular fishing destination.

Navigational challenges along the Outer Banks posed by the Diamond Shoals area off Cape Hatteras have caused thousands of shipwrecks, with an unknown number of lives lost. The shifting series of shallow underwater sandbars reaching eight miles out from Cape Hatteras made navigating extremely hard and very dangerous.

Cape Hatteras has been a deadly trap for sailors for many centuries. It's estimated that more than one thousand shipwrecks have been recorded on the shifting sandbars.

In the 1800s, several lighthouses were built to safely guide ships around the dangerous area. In 1848, the U.S. Life-Saving Service was created with stations along the shoreline. The purpose of these stations was to make every effort to save the people on board in the event of a shipwreck. The lifesaving stations eventually became part of the Coast Guard.

Hurricanes, strong wind, high waves, treacherous shorelines—all have posed problems for ships and their crews. The area along the North Carolina coast has become known as the Graveyard of the Atlantic.

One of the most recent shipwrecks took place in 1981, when the *Lois Joyce*, a one-hundred-foot commercial fishing trawler, was attempting to enter Oregon Inlet during a storm. The crew of the *Lois Joyce* was rescued by a Coast Guard helicopter.

Legend has it that Nags Head got its name from wreckers tying lanterns around the necks of ponies and letting them wander up and down the beach. This confused incoming ships, causing them to mistake the motion of the lanterns for the light on a ship.

Curse of Bath

ath was established in 1705 by explorer John Lawson, who laid out the town along the Pamlico River. The town was named in honor of John Granville, the Earl of Bath and one of the Lords Proprietors.

In the eighteenth century, Bath was an important part of the Carolina colonies. The shipping traffic was heavy from the many ships traveling across the Atlantic that would stop at Bath. Ship captains would stop there to resupply their ships and to sell and trade their goods. Not everything brought in was legitimate, but nobody was asking any questions. Pirates appreciated Bath's no-questions-asked policy. Bath was conveniently located, so ships could quickly sail away if the British navy happened to drop in.

With all the money and ships coming into Bath, it developed a reputation for liquor, wild parties and a good time for everybody.

One day, traveling evangelist George Whitefield rode into Bath. With the Bible in one hand and a fire-and-brimstone sermon, he was going to convert the sinners. Whitefield was a famous traveling evangelist who preached hellfire and damnation against the evils of cursing, drinking, dancing and any other sin he could think up. Whitefield believed that more than any other sin, dancing was the vehicle that the devil used to send men and women to hell.

Whitefield was a prime mover of the wave of religious fervor that swept the colonies before the Civil War.

Like many preachers of today, Whitefield was a grand showman. He always traveled in a wagon, and one of his pieces of evangelical stagecraft

was a coffin. Whitefield used the coffin to illustrate the fact that he was prepared for death and knew his own salvation was going to take him to heaven. Whitefield even slept in his coffin to avoid the questionable goings-on at the inn.

Whitefield's preaching of eternal damnation and sleeping in a coffin was not too welcome in Bath. One day, Whitefield was met by a delegation of concerned citizens who indicated quite strongly that he might want to leave Bath. The preacher took the hint, and as he was leaving, he removed his shoe and waved it at the town, shouting, "If a place won't listen to the Word, shake the dust of the town off your feet and the town shall be cursed."

Another source says Whitefield voluntarily left the village when he failed in his attempt to reform the good citizens of Bath. As Whitefield left, he shouted back at the sinners: "There's a place in the Bible that says if a place won't listen to the Word shake the dust of the town off your feet, and the town shall be cursed for a hundred years.

Shortly after Whitefield left, Bath began to decline. Ships started going to other ports. The rich were moving away, and no newcomers took their place. By the middle of the nineteenth century, Bath had dwindled to a sleepy little hamlet hardly worthy of being called a town.

Over the years, Whitefield's curse from heaven has become an enduring legend as to why Bath did not prosper.

Today, Bath remains a small community steeped in history but otherwise forgotten. Historic Bath is located in Beaufort County, North Carolina. It's a lovely place to spend the day walking around the historic town.

Eight Schooners Vanish

On August 17, 1893, two thousand miles east of the Caribbean in the Cape Verde Islands, a hurricane was taking shape. As it headed west, it gained intensity. On August 18, the storm became a hurricane, and it passed north of Haiti and between Cuba and Bermuda, moving faster than most hurricanes do. It appeared that its destination was Charleston, South Carolina. The hurricane struck Charleston during the heat of the summer, during a time when tourists crowded the South Carolina beaches for vacation. Property damage was estimated at $10 million, and hundreds of lives were lost.

The hurricane hit so unexpectedly that ships caught in the vicinity had no warning until they were broadsided by the hurricane-force winds. Eight schooners vanished in the path of the hurricane off the coast of North Carolina:

- The schooner *Mary J. Cook* from Port Royal, South Carolina, to Boston, Massachusetts, carrying lumber, seven crew and passengers were on board
- The schooner *L.A. Burnham* from Savannah, Georgia, to Portland, Maine, carrying lumber, seven crew were on board.
- The schooner *A.R. Weeks* from Satilla Bluffs, Georgia, to Elizabeth Port, New Jersey, carrying lumber, eight crew were on board.

- The schooner *George W. Fenimore* from Brunswick, Georgia, to Philadelphia, Pennsylvania, carrying lumber, eight crew were on board
- The schooner *Oliver H. Booth* from Brunswick, Georgia, to Washington, D.C., carrying lumber, six crew were on board
- The schooner *Gertie M. Rickerson* from New York to Caibarién, Cuba, carrying general cargo, seven crew were on board
- The schooner *John S. Case* from Jonesport, Maine, to Puerto Plato, Santo Domingo, carrying lumber, six crew were on board
- The schooner *Lizzie May* from New York to Fernandina, Florida, in ballast, six crew were on board

It is unknown when the hurricane hit the eight schooners; none was ever seen again. There has been no trace of the crew or passengers. No debris or cargo was ever found. They simply vanished in the hurricane off the North Carolina coast.

Mysterious Coastal Booms

S eneca guns, sky quakes, sonic booms or whatever name you give them have been heard as far back as the 1800s over Lake Seneca in New York.

There are several theories about what causes coastal booms. None of the theories has ever been proven: gas being released from the ocean floor, UFOs, a crack in our dimension, a shift in time, meteorites entering our atmosphere or exploding. They have also been considered the voice of an angry god.

One theory of the paranormal is that the sound comes from the ghosts of American Indians firing guns to disturb the descendants of those who drove them off their land.

More reasonable theories are earthquakes or the shift in tectonic plates. However, seismologists have not been able to match the time of the booms to earthquakes or the shifts in the plates. Offshore thunderstorms are part of another theory, but meteorologists report no storms at the time.

The military could be responsible for some of them, but the military denies any knowledge of their existence. Sonic booms have been heard long before we were able to break the sound barrier.

Neither scientists nor meteorologists have an answer as to what causes the sonic booms. They have been baffled for years. There are no definitive answers.

Jack C. Hall, professor of geology and chair of the Department of Environmental Studies at the University of North Carolina–Wilmington, said, "It's safe to rule out tectonic plate movement. With no measurable

movement of the earth's crust it makes more sense to look to the atmosphere for the answers."

Dr. David Hill, geophysicist with the U.S. Geological Survey in Menlo Park, California, added, "I don't think it's ghosts and I don't think it's aliens."

A prominent geophysicist from the University of North Carolina–Chapel Hill says that "earthquakes have nothing to do with it."

The sonic booms are heard up and down the East Coast, but they are particularly concentrated off the coast of North and South Carolina. Occurring mostly during the spring and fall, they shake windows and doors, and occasionally, whole buildings shake as if hit by a strong gust of wind.

They have been heard in Dare County, Currituck County, the Outer Banks, Varnamtown, Brunswick County fishing villages, Carolina Beach, Mayfaire, Pine Valley, southeastern North Carolina, Wrightsville Beach, Craven County and Fort Fisher.

Possible explanations are rock bursts, mud volcanoes, explosive venting of gas, storm-driven waves, tsunamis and booming sand.

The Sound of the Devil's Drum

Currituck County was very different in the early years. It was quiet. There were no trains, cars or planes—nothing to disrupt the peaceful quiet. On a clear night, when you looked at the stars, you could see forever. On a calm day, you could hear a bird singing from a mile away—not like it is now.

Sometimes on a quiet day or night you could hear a strange sound, described as distant thunder. Civil War veterans said it sounded like cannons in the distance. No one could agree on what the sound was or the direction it was coming from. Sometimes it sounded like it was coming from the ocean, other times from over the land.

The citizens of Currituck County finally agreed on a name for the mysterious sound, "The Devil's Drum." Each time they heard the sound, a tragedy always followed. A person died.

Over the years, there was speculation that the sound was the result of two Atlantic currents that sometimes collided at Diamond Shoals. However, the Devil's Drum has not been heard in a long time. The sound has never been explained or the origin discovered. Is the Devil's Drum still beating and just being covered up by progress?

Pender County Bigfoot

The earliest recorded sightings of Bigfoot date back to the sixteenth century

On Monday, August 15, 2011, in Pender County, North Carolina, at approximately 5:10 a.m., a man was traveling toward Jacksonville, North Carolina, driving about fifty miles per hour on Highway 53, a straight road with woods on both sides.

The driver spotted a large hairy creature standing six and a half to seven feet tall. He estimated it weighed about four hundred pounds. It had rusty-brown hair and didn't appear to have much if any neck and human-like hands. It ran across the highway about fifty feet in front of his car. Four steps across the highway and it was gone.

Lost Colony of Roanoke

The mystery of the Lost Colony of Roanoke Island has intrigued Americans for centuries. After 425, years this sixteenth-century settlement is more than a legend.

In July 1587, over thirty years before the Pilgrims landed at Plymouth Rock, a group of 117 men, women and children arrived on Roanoke Island. They made history as the first attempt at establishing a permanent English settlement in America. Roanoke Island is one of a chain of barrier islands now known as the Outer Banks off the coast of North Carolina.

Part of the group included John White, his expecting daughter, Eleanor Dare, and her husband, Ananias Dare, who were recruited by Sir Walter Raleigh. The ships were unloaded, and they began repairs on an old earthen fort previously built on the island. On August 18, 1587, Eleanor Dare gave birth to her baby girl. She named the child Virginia. Virginia Dare earned the distinction of being the first English child born in the New World.

Ten days later, on August 28, 1587, John White sailed from the English colony to return home for supplies. The colony consisted of eighty-nine men, seventeen women and eleven children.

White intended to return to the Roanoke Island colony the following year, but with England's naval war with Spain and the threat of a Spanish invasion, White was delayed. Queen Elizabeth I had called on every ship to confront the Spanish Armada. Three years later, White returned with the supplies. He arrived on August 18, 1590, his granddaughter's third birthday.

He found the colony abandoned, with no trace of the settlers. The only clues to their fate were the word *Croatoan* carved into a tree (another source says it was carved on the palisades) and the letters *CRO* carved into a tree. This was the name of a nearby island and home to the English-speaking Croatoan Indian Manteo. There was no sign of any violence. A later search of Croatoan Island found no trace of the settlers. White was forced to sail on, not knowing the fate of his family or the other settlers.

There are many rumors as to the fate of the Roanoke Colony. One thought is that the settlers took refuge with the Croatoans. That's why *Croatoan* was carved into a tree. Others think they were murdered by Native Americans. Another theory is that the Spanish in Florida destroyed the colony. The colonists might have tried to sail back to England and got lost at sea, or they might have been absorbed into friendly Native American tribes and moved farther inland.

From 1937 to 1941, a series of stones were discovered that claimed to have been written by Eleanor Dare, mother of Virginia Dare. They told of the colonists travels and ultimately their death. However, historians believe these stones are a fraud. Perhaps the most famous missing persons case is the Lost Colony of Roanoke.

THE LEGENDS OF VIRGINIA DARE

While living with the natives, Virginia had a dispute with a native witch doctor. The witch doctor had his eyes on her, but she didn't share his affections. The legend says he turned her into a white doe. People believe that the ghost of Virginia Dare still roams Roanoke Island in the form of a doe. Local islanders have reported seeing a white doe on the island.

Chico, a jealous sorcerer refused by Virginia Dare, put a curse on the girl and transformed her into a white doe.

Okisko and Wanchese were both tracking the white doe. Neither knew the other was tracking her. Both had been tracking her for weeks. Okisko was determined to return her to her true form with a magic arrow. Wanchese intended to kill her. They came upon her at the same time, while she was drinking from a pool in the forest. Okisko saw his love; Wanchese saw his prey. Both shot, striking her at the same time. Okisko's arrow transformed the deer into Virginia Dare, the girl he loved. Wanchese's killed her. Okisko carried her lifeless body back to the fort and buried her in the center.

By the pool where the white doe was drinking, a grapevine grew, bearing the sweetest grapes ever tasted. The juice from the grapes was blood red. This was the scuppernong grape. North Carolina's first wines were made from the scuppernong.

ARCHAEOLOGICAL EVIDENCE

In 1998, East Carolina University organized the Croatoan Project. A team sent to Hatteras Island uncovered a ten-karat-gold, sixteenth-century English signet ring, some gun flint and two copper farthings. Additional finds were a small slate that could have been used as a writing tablet and a light sword similar to those used in England in the sixteenth century.

Genealogists traced the lion crest on the ring to the Kendall coat of arms. They concluded the ring most likely belonged to a Master Kendall, who lived in the Roanoke Colony from 1585 to 1586.

64

Fort Raleigh

I n the 1800s and 1900s, locals referred to a large grassy mound within the Fort Raleigh National Historic Site as Fort Raleigh. The original fort was an earthen fortification made of wood and mud. Over the centuries, it has deteriorated into the ground, leaving a large mound.

In the 1930s and 1940s, archaeological digs unearthed some historic treasures—an Indian pipe, an iron sickle and metal counters—from the original site, lending credibility to the theory that it was the fort from the original Lost Colony. In 1941, Fort Raleigh was deemed a historical site. It attracted amateur and professional historians nationwide. In the 1950s, the earthen fort was restored. Today, visitors can see a large lumpy mound, the last original structural relic of the original lost colony. The area is managed by the National Park Service.

The Fort Raleigh site is supposedly haunted by the ghost of Virginia Dare, the first English child to be born in the New World.

The visitors' center is open every day, except Christmas, from 9:00 a.m. to 5:00 p.m. The center provides an in-depth introduction to the history surrounding the historic site. It is located in Dare County.

The Lost Colony outdoor drama is one of the most popular and longest-running nighttime attractions on the Outer Banks. It is staged inside the Fort Raleigh National Historic Site at the Waterside Theatre. The play dates back to July 4, 1937. Franklin D. Roosevelt saw the play one month after it opened, and Andy Griffith was the most famous actor to appear in *The Lost Colony* pageant.

Elizabethan Gardens

Within the weathered brick walls are gorgeous roses, hydrangeas, camellias, crape myrtles, bulb flowers, butterfly bushes and seasonal flowers. It has a sunken garden and a thatched gazebo and a gift and plant store. The Elizabethan Gardens is open year-round.

Other events happening in the gardens are the harvest days, the Easter Eggstravaganza and the monthlong winter lights, when the gardens are illuminated by hundreds of thousands of Christmas lights. The garden covers more than ten acres and includes a replica Tudor gatehouse. For your walking enjoyment, the Elizabethan Gardens has the Thomas Harriot Nature Trail and the Freedom Trail. There is also a small souvenir shop.

The site was established on April 5, 1941, and was listed in the National Register of Historic Places on October 15, 1966.

The fate of the lost colony that disappeared over four hundred years ago still remains a mystery.

A stone marker commemorates Virginia Dare and the members of the Fort Raleigh Lost Colony. The front reads:

On this site, in July-August 1585 (O.S.) colonists, sent out from England by Sir Walter Raleigh, built a fort, called by them "The new fort in Virginia" These colonists were the first settlers of the English race in America. They returned to England in July 1586, with Sir Francis Drake. Near this place was born, on the 18th of August 1587, Virginia Dare, the first child of English parents born in America—daughter of Ananias Dare and Eleanor White, his wife, members of another band of colonists sent out by Sir Walter Raleigh in 1587. On Sunday, August 20, 1587, Virginia Dare was baptized. Manteo, the friendly Chief of the Hatteras Indians had been baptized on the Sunday preceding. These baptisms are the first known celebrations of a Christian sacrament in the territory of the thirteen original United States

Sponsored by the Roanoke Colony Memorial Association, the marker was dedicated on November 24, 1896.

Buffalo City

uffalo City was the largest community in Dare County, North Carolina, around the turn of the nineteenth century. It was a logging and moonshine town in East Lake Township located on the mainland. Buffalo City was born in Civil War times and grew into a haven for moonshine makers.

Shortly after the Civil War, the Buffalo Timber Company of New York discovered North Carolina had rich timberland. Buffalo City was built on the north side of Milltail Creek, and the Buffalo Timber Company bought 100,000 acres on the Dare County mainland and started operations in 1888.

The Buffalo Timber Company brought in hundreds of Russian laborers to build the town and lay the railroad tracks. Many of the Russian immigrants stayed and worked in the logging town. This became the largest logging operation in northeastern North Carolina. They built sawmills, a hotel, a church, a general store and a schoolhouse, as well as company homes for the laborers. The first post office opened on October 11, 1889. Charles A. Whallou delivered the mail. Buffalo City was never incorporated and had no law enforcement.

The loggers were paid in aluminum coins that they had to spend at the company stores. Workers left their homes each morning to go into the woods and cut cypress, juniper and pine for fifty cents a day.

After depleting the trees, the Buffalo Timber Company shut down operations, including the post office, in 1903. In 1907, the Dare Company purchased the land and resumed logging. There was an attempt to change

the town's name to Daresville, but that name never stuck. Buffalo City's population grew to three thousand, making it the largest town in Dare County. The Duvall brothers bought the land but never made a go of it. Then the Black Bear Lumber Company bought it. It tried to expand the lumber business but failed to do so. By the early 1920s, the logging industry had come to an end in Buffalo City.

As the lumber business was dwindling, the residents had to find another way to supplement their income. Making moonshine was the occupation of choice. Almost every family in Buffalo City operated a still or was involved somehow in the bootleg liquor business.

In 1920, after the Eighteenth Amendment outlawed spirits, prohibition laws were passed in the United States. North Carolina was the first southern state to pass a referendum banning alcohol on May 26, 1908, and it remained a dry state until 1937.

Large amounts of sugar regularly arrived on the tugboat *Hattie Creef*, supplying the dozens of stills scattered around Buffalo City. With its isolated location and access to natural waterways, it was an ideal spot for a large-scale bootlegging operation. Buffalo City's famous East Lake Whisky was sold in speakeasies in Washington, D.C., and New York City. It used rye instead of corn. By the mid-1920s, Buffalo City was known as the moonshine capital of the United States.

In order to distribute the whiskey, it was often put in five-gallon jugs sealed with wax corks. The jugs were tied to a line that trailed behind boats, so if the feds pursued a booze-toting boat, the crew simply cut the lines, letting the jugs sink to the bottom. They would go back and get them later. Federal revenuers knew Buffalo City's reputation and made some late-night raids that shut down a few stills. When Prohibition ended in 1933, the demand for Buffalo City whiskey dried up. Buffalo City once again fell on hard times.

An outbreak of cholera, typhoid, smallpox and the flu that swept through the community in the 1940s caused a decline in population to about one hundred people. Then the sawmill closed in the 1950s, and Buffalo City was abandoned.

In 1984, the U.S. Fish and Wildlife Service acquired the land and formed the Alligator River National Wildlife Refuge. It covers 152,000 acres. Today, Buffalo City belongs to the swamp. All that remains of Buffalo City is a sign at the entrance to a gravel path that reads, "Buffalo City Road."

There is no telling how many bodies are buried around the old Buffalo City area.

Hatteras Island Spaceship

In 1970, Doctor Lee and his wife, Mary Jane Russo, were on vacation in the Outer Banks of North Carolina. They came across a piece of land that they decided to buy and needed a house to put on the property. While thumbing through *The Last Whole Earth* catalogue they saw the Futuro House, a UFO-shaped fiberglass-reinforced polyester plastic home. It was built in the 1960s by Finnish architect Matti Suuronen. It was originally designed as a ski cabin. It would be easy to heat and simple to set up in the rough mountain locations. The Russos decided that's what they needed.

In 1972, they bought a Futuro home and had it transported from New Jersey to Hatteras Island. A local builder helped assemble the Futuro. Later, a dozen or so friends helped the Russos get everything inside and installed.

The Russos used it as a holiday home and for getaways from the busy life in Baltimore until 1983, when they donated it to the local fire department. The fire department was thinking of burning it for practice but instead decided to raffle it off.

Some call it an eyesore, but the silver spaceship is probably one of the most fascinating objects on Hatteras Island. The new owner, Captain Jim Bagwell, says it is the second most photographed thing on Hatteras Island, next to the Cape Hatteras Lighthouse. He bought the spaceship about twenty years ago from a couple in Hatteras Village. It has been in two other locations in Fresco, the Scotch Bonnet Marina and about a mile south. It has been a flea market, an office and an Out of This World hotdog stand.

The present owner has been served five or six stop work orders, and the Dare County Planning Department has denied his request to make alien ice cream. He can't get water or electricity hooked up to the spaceship.

The planning department hates Bagwell, but the tourism board loves him.

The Futuro house (UFO) is visible from Highway 12, with a green alien looking out of one of the windows.

Wilmington Sea Serpent

S ightings of mysterious sea monsters have been reported since the beginning if recorded history. Of course, most have been identified.
 Local Indian legend reports a giant snake lived in the ocean at the mouth of the Cape Fear River. The sightings of giant sea serpents have come from this area for centuries.

The first written record was made by Spanish explorer Giovanni da Verrazzano in 1524. He wrote that during the night, one of his men saw a great snake resting upon the waves not far from the shore of the Cape Fear River.

In 1732, the Earl of Wilmington, Spencer Compton, reported seeing something surface in the water of the Cape Fear River. James Calden, a Union soldier, took reports on the sea serpent when he was stationed near the Cape Fear River in 1865. He described it as being a dull gray, about four feet wide and forty feet long. The head appeared to be about two and a half feet across, two feet thick and about five feet long. The serpent was named Willie in honor of the town of Wilmington.

Willie the Sea Serpent, or at least one of his descendants, is still hanging around Wilmington.

In 1947, the *Santa Clara III* was en route to Colombia, South America, in North Carolina waters when Third Officer John Axelsow observed a sea serpent from the bridge. Two other crewmen saw the snake as well. They could not maneuver the ship around and struck the sea serpent. It sank out of sight.

In 1968, a paleontologist came to look for Willie but didn't have any success. He never saw it but did write down the information he was given by the locals. The scientist said it might be a *Basilosaurus*, a distant relative of the whale. However, if it is, the books will have to be rewritten. The Basilosaurus was thought to have died out over twenty million years ago.

Fishermen still see Willie the Sea Serpent occasionally.

Tabbot Cruthfield, a local historian, helped to set up a small exhibit dedicated to Willie at the Wilmington Historical Museum.

U.S. Navy Ship Encounters UFO

In the summer of 1986, a lookout was standing watch on the USS *Edenton* (ATS 1). No name or rank was listed in the reports for the lookout. He was posted outside on top of the bridge, and his job was to report all contacts seen in the ocean or in the sky.

It was about 11:00 p.m., and the night sky was clear. As he watched, four red circular lights appeared. The lights were an undetermined distance

from one another and formed a square. They were too big to be aircraft running lights. The lights were about twenty degrees above the horizon and estimated at about one mile from the ship. They were visible and very bright in the night sky.

The moon was shining, and the stars were visible. The lights were stationary and could clearly be distinguished from the stars. The lookout called down to the bridge, informing the conning officer of a possible UFO. He relayed the message twice before getting the bridge officers' attention.

The four lights darted toward the horizon quickly. The lower lights went first, with the top two lights following; then the four lights shot straight up and out of sight.

The conning officer and everyone on the bridge saw the lights, and the event was recorded in the ship's log as a UFO sighting.

In about a half an hour, the radiation detection system on the bridge started going off. The ship had taken a hit of 385 roentgens in about one minute. The captain and chief in charge of the radiation metering equipment onboard ship were called to the bridge. Other meters throughout the ship were indicating the same amount of roentgens. The captain ordered his subordinates not to log the incident concerning the radiation exposure in the ship's log. No one ever spoke of what happened again.

As an indication of the strength of the radiation received that night on board the USS *Edenton*, the people involved in the Project Trinity Experiment in 1945 at ground zero received between one and six roentgens.

Cedar Grove Cemetery
and the Weeping Arch

C edar Grove Cemetery was established at the end of the eighteenth century in New Bern in Craven County, North Carolina. It covers thirteen acres and serves as the graveyard for the Christ Episcopal Church.

Christ Episcopal Church is the third-oldest church in North Carolina. The church was founded in 1715 as Craven Parish. The graveyard originally served the first church building, constructed in 1752.

During the yellow fever epidemic that ravaged New Bern, North Carolina, the cemetery for the Christ Episcopal Church was no longer able to accept the victims—it had run out of room.

In 1799, the church obtained a nearby field on Queen Street for another cemetery. In 1853, the church turned over complete control of the cemetery on Queen Street to the City of New Bern. In the mid-nineteenth century, it was renamed Cedar Grove Cemetery.

In 1854, a towering triple-arched gateway was erected along with a wall around the graveyard. The arch was made of stone called shell stone quarried locally. Shell stone is made up of seashells and fossilized remains of sea creatures.

What makes this arch different from other arches? People say it weeps. When people walk through the arch, it either cries or bleeds on them. The tears range in color from a thin rust-tinted liquid to a thick deep-red substance.

Legend says that during a funeral procession into the cemetery, if a pallbearer is hit by a drop of this mysterious liquid, he or she will be the next

one of the group to die and be carried into the cemetery. The strange thing is, the old-timers can give you names and dates of such occurrences. The arch doesn't just cry at funerals.

People who have experienced it say it was like the stone was crying in mourning for the dearly departed. This is why it earned the name the Weeping Arch.

People who have gotten the strange liquid on their clothes say it washes out and doesn't leave a stain.

There is a Confederate soldier statue in the center of the cemetery on top of a crypt containing three hundred Confederate soldiers. The long-dead soldiers are seen roaming throughout the cemetery both day and night.

The Weeping Arch is still at the cemetery and still crying. It can be found on Queen Street.

There could be a logical explanation: coquina is a very porous stone. The top of the arch is a flat surface, and the tears may be rainwater that collects on top and slowly seeps through the stone, picking up minerals to change its color as it seeps slowly out of the arch.

The Earl of Craven Questers' chapter conducts tours every Saturday. The local chapter consists of twenty-one members who use the money they raise to help with the preservation and restoration of Cedar Grove Cemetery.

Notable Burials

Charles Abernethy, congressman, 1872–1955
Graham Barden, congressman, 1896–1967
Samuel Brinson, congressman, 1870–1922
Caleb Bradham, Pepsi inventor, 1867–1934
Mary Bayard Clark, author, no date given
Richard Donnell, congressman, 1820–1867
William Gaston, congressman, 1788–1844
Moses Griffin, educator, no date given
Robert Ransom Jr., Confederate general, 1828–1892
Charles Shepard, congressman, 1808–1843
Furnifold Simmons, congressman, 1854–1940

John Stanly, congressman, 1774–1833
Charles Thomas, congressman, 1827–1891 (father)
Charles Thomas, congressman, 1861–1931
William Washington, congressman, 1854–1940
William Williams, artist, 1813–1860

70

Porpoise Sal

*A*fter the storm of 1899 wreaked havoc on Diamond City, the beach was left littered with parts of ships, houses and everything else that was on the island. A beautiful young woman was found tied to what appeared to be a hatch cover from a ship. She was about half drowned but still breathing, struggling in an attempt to free herself from the ropes. How could anyone live through that storm tied to a hatch cover? None of the islanders had ever seen her before. Where did she come from? She was a beautiful woman with black hair, dressed in white.

Word quickly spread, and the island women came out to help the strange woman. They brought her food, drink and clothing. The stranger didn't speak. Everyone who saw her was puzzled by her behavior. Every morning, she would go swimming, but not alone. There was always a group of dolphins that surrounded her. She became known in the community as a harmless curiosity.

One day, someone spotted something floating out to sea. It was the hatch cover that Sal had come ashore on one year earlier. She was standing on to top of the hatch cover. This would be the last time the islanders would see Sal, as she dived off the hatch and into the sea

Although this story is retold here with a different beginning, the basic part of the story is the same.

One day, a large object was seen floating in the water on an August morning. A group of men went out to investigate the object. As they reached it, they were surprised to see a giant barrel floating in the sea. The men

hauled it to shore to investigate. They heard something moving inside and quickly tore off the barrel head. To their surprise, it was a beautiful woman with black hair dressed entirely in white. The men asked her who she was and if she had been in a shipwreck. Taking her time to answer, she said, "The killing must stop." She repeated it again: "The killing must stop." When asked her name, she said, "Sallie, Sallie."

Word quickly spread and the island women came out to help her, bringing food, drink and clothes.

The men decided to haul off the old barrel, but the mysterious woman said, "Mine." The men stopped, and she set up housekeeping in the old barrel. The people of Diamond City gave her the necessary things to furnish her barrel fairly comfortably.

Everyone who saw her was puzzled by her behavior. She went swimming every morning—but not alone There was always a group of dolphins that surrounded her. The people began calling her Porpoise Sal, and she became known in the community as a harmless curiosity.

As the spring approached, Porpoise Sal kept telling the people of the town, "The killing must stop."

As February rolled around, the whaling ships set out. When the first whale was brought in, Porpoise Sal was weeping. With each passing day, Porpoise Sal seemed to grow sadder.

On the night before the anniversary of her arrival, the skies grew dark, the wind grew strong and the sea raised its fury. The people on the island

knew what was coming, a hurricane. Porpoise Sal stopped a fisherman and told him, "You have been warned."

The hurricane struck that night. Before the night was over, the entire island was underwater. As the morning dawned and the sun came up, Diamond City was no more. Every building was destroyed or damaged; every boat that wasn't damaged or destroyed washed out to sea.

Then someone spotted something floating out to sea. It was the barrel that Sal had come ashore in one year earlier. She was standing on to top of the barrel. This would be the last time the islanders would see Sal, as she dived off the barrel and into the sea. The barrel began to slowly sink as the people watched. All that was left is a memory of a mysterious woman from the sea and a warning that was ignored by everyone. Diamond City is protected as part of the Cape Lookout National Seashore.

There's another version of the story that takes place after the divesting hurricane. The women of the island noticed two things when they got to the mysterious woman of the sea: one, she wore a plain gold wedding band on her left hand, and two, she was pregnant. When the ladies asked her name, she just said "Sallie" over and over. The people of Diamond City who were left after the storm accepted Sallie. Her strange conduct and mysterious behavior provided the islanders with a never-ending source of speculation and gossip.

The island people believed that Sallie had second sight. From the beginning of her story, she assured the people of the island that there would be a terrible August storm, their punishment for killing the poor porpoises. Some of the people believed she was touched in the head. She was treated with the respect accorded to those who suffer from mental illness.

Neither Diamond City nor the island was ever the same after the great hurricane of 1899. Porpoise Sal moved from house to house at the invitation of the remaining islanders. She was never satisfied. A powerful wind blew in an empty vat or barrel, and it became Porpoise Sal's home. The men of the island took the vat and moved it up on the beach, making a comfortable little home for Sal.

That winter, Sal's baby was born with the assistance of the island midwives. She named him Mark. Sal educated her son the best she could. She was very firm when she spoke to her son about the sea and about fearing God.

One day, Sal saw some ambergris lying in the wash. She scooped it up and ran to her house. She told the people of her great find, and of course, most were happy for her. There were two, however, who weren't, and they broke into her house and demanded the ambergris. With a knife to her throat, she

was scared to talk. They drug Sal outside and kicked loose the timbers that held her house in place. The house started rolling toward the sea. Her young son was still in the house. When the house hit the water, Mark came flying out. The two men went after the ambergris, and Sal went after Mark. Sal plunged into the water and caught Mark by the hand. The two men rushed into the water after the ambergris. Holding on to the ambergris, they were swept out to sea. The neighbors rushed to the rescue of Sal and Mark. By the end of the day, Sal's home had been rolled back up the sand hill to a place with more security.

When Mark was seventeen he ran away to sea. He signed on to a merchant ship and occasionally wrote Sal and sent her money. His letters arrived further and further apart, then finally stopped coming.

Fishermen occasionally came by to see Sal. The men from Lookout Lighthouse checked on her periodically. When neighbors brought their children to visit, she would tell them stories of the sea and its creatures. Her fame as a storyteller soon spread.

One August morning, the barometer was falling and the people knew what was coming. When the Coast Guard checked on Sal, they found her house empty and the front door open. Everything in the house was in place. They checked back that evening but still no sign of Sal. Sal was never seen again. True story or campfire tale? You decide.

One Final Thought

The nights and shadows are getting longer, the temperature is dropping and a chill is in the air. Now it's time to explore the darker side of history, so legends tell us. It's time to visit places associated with the legends of ghosts and other strange things. When one is doing research into the unknown, the trail leads to a world of uncertainty where anything can happen. We are stepping into the world of the unexplained. In my forty-something years of dabbling into things best left alone, I have never found that the weather conditions or the time of year has any effect on the appearance of ghosts. They appear when they want.

Some reject ghosts and other strange things just because they don't fit into their limited knowledge. They may never know the truth because of their fear of the unknown. We believe in saints, angels and deities that we cannot see without question yet refuse to believe anything else could exist.

The power of a myth or legend is not in it being right or wrong but in it being believed. We are tempted to dismiss stories that have become legends and myths simply as fairytales or being born from our overactive imaginations. There are places and times when strange and unexplainable things happen and will continue to happen. Much of what we dismiss as unrealistic and irrational just might actually exist. Is this just in our minds, or is there something else out there? Face the facts: we might not be alone. If you listen closely enough, you can hear the echoes of a storied past, a time long forgotten. There is more to history if you know where, when and how to look for it. The answers you find may not be what you're looking for.

People with open minds believe that ghosts can exist. Reputable sources have reported ghost ships, ghost aircraft and other ghostly objects. Some say that objects cannot return as a ghost. There have been many reports of ships, planes and cars appearing out of nowhere and then fading back into nothingness. Maybe they're not ghosts at all. Could these unearthly visitors be trapped in time, making an occasional visit back to the real world? Could there be a vortex that lets these unexplained sightings enter our world for just a minute? What is the authority that restricts ghosts to only the once living people or animals?

Some believe that there could be a soul and a spirit in the living body. When the body dies, the soul goes on to the heavenly realm and the spirit lingers here on earth to roam forever. And that, dear readers, is what we see here on earth as ghosts. How do we account for a lot of ghosts that appear fully dressed? They are wearing the same clothes they died in. Then there are those who died in a hospital or in bed at home but come back dressed in other clothes, such as a military uniform. There are a lot of theories to the ghost question and a lot more coming. But we'll never know the answer until we sit down and have a conversation with a ghost.

I am not trying to prove or disprove anything. I am just reporting the stories as I have found them. Belief or disbelief is up to the individual. Those of us who have dedicated part of our time to investigating the strange and unknown realize that the dangers out there could be plentiful. While there is something out there, what it is or where it comes from has yet to be discovered. There are too many credible witnesses for there not to be something lurking around the corner (not every corner).

To ghost hunters, the Carolinas are a treasure-trove of ghostly legends. The horrors of the Revolutionary War, the Civil War and the hundreds of thousands untimely removed from life while settling the New World have left their imprints—to this day, do they still go about their daily duties?

There's nothing to prove the existence of ghosts. But there's nothing that proves they don't exist. As I have shared in my books, many stories about the paranormal have been handed down, some for hundreds of years. There has to be a modicum of truth for a story to continue to survive. If you believe the stories and legends, then you have to believe that ghosts or something exists.

Belief and a willingness to explore the unknown are two vital ingredients required to someday prove that ghosts do or do not exist. However, the methodology used now may never lead to a satisfactory conclusion.

Some say that around every corner there's a ghost. Others say around every corner there's a gullible person. A number of the locations discussed in this book are on private property. Get permission before you explore.

Bibliography

Books

Barnes, Jay, and Alan J. Watson. *North Carolina's Hurricane History*. Chapel Hill: University of North Carolina Press, 2013.

Carmichael, Sherman. *Forgotten Tales of South Carolina*. Charleston, SC: The History Press, 2011.

———. *Legends and Lore of South Carolina*. Charleston, SC: The History Press, 2012.

Manley, Roger, Mark Moran and Mark Sceurman. *Weird Carolinas*. New York: Sterling Publishing, 2007.

Roberts, Nancy. *Ghosts from the Coast*. Chapel Hill: University of North Carolina Press, 2001.

Roberts, Nancy, and Bruce Roberts. *Illustrated Guide to Ghosts and Mysterious Occurrences in the Old North State*. Asheville, NC: Bright Mountain Books, 1959.

Schlosser, S.E., and Paul G. Hoffman. *Spooky North Carolina: Tales of Hauntings, Strange Happenings, and Other Local Lore*. Guilford, CT: Globe Pequot Press, 2009.

Stick, David. *Graveyard of the Atlantic: Shipwrecks off the North Carolina Coast*. Chapel Hill: University of North Carolina Press, 1952.

Traylor, Waverly. *The Great Dismal Swamp: In Myth and Legend*. Pittsburgh, PA: RoseDog Books, 2010.

Whedbee, Charles Harry. *The Flaming Ship of Ocracoke and Other Tales of the Outer Banks*. Winston-Salem, NC: John F. Blair, 1971.

News

American Heritage
Banger (ME) Daily Whig and Courier
Charlotte (NC) Daily Observer
Charlotte (NC) Observer
Chronicle Telegram (Elyria, OH)
Coastal Observer (Pawleys Island, SC)
Daily Kennebec (ME) Journal
Deseret News (Salt Lake City, UT)
News and Observer (Raleigh, NC)
New York Herald
New York Times
North Beach Sun (Outer Banks, NC)
Our State (Greensboro, NC)
Robesonian (Lumberton, NC)
Southport (NC) Times
Star News (Wilmington, NC)
Sun Journal (New Bern, NC)
Virginian Pilot (Norfolk, VA)
Washington (D.C.) Post
Wilmington (NC) Advertiser
Wilmington (NC) Daily Herald
Wilmington (NC) Gazette

Government

National Governors Association
National Park Service
Research Branch of North Carolina Office of Archives and History
United States Coast Guard

Websites

A

activerail.com
ahauntedworld.wordpress.com
ah.dcr.state.nc.us
albemarleoperahouse.com
alloveralbany.com
americanfolklore.net
angelsghosts.com
archaeologyncdcr.gov
areyouterrified.blogspot.com
atlasobscura.com

B

battleshipnc.com
beaufortartist.blogspot.com
bellamymansion.org
bermudatriangle.org
bfro.net
biography.com
blog.kittyhawk.com

C

candidslice.com
carolinabeachtoday.com
carolinaouterbanks.com
carolinaweekly.com
chloesblog.bigmill.com
christianpost.com
cinematreasures.org
coastalcottageobx.com
coastalguide.com
coastalreviewonline.com
circanceast.beaufortccc.edu
currituecklight.com

D

deomnis.net
dismalswampwilcomecenter.com
divehatteras.com
downeasttour.com

E

epa.gov
exploreyourspirit.com

F

fellowshipoftheminds.com
findagrave.com

G

gendisasters.com

H

hamptonroads.com
hauntednc.com
hauntedplaces.com
hauntedplaces.org
hauntedstories.net
haxan.com
historicmysterious.com
hubpages.com
hydecountychamber.org

I

ibiblio.org
islandfreepress.org
islandlifenc.com

L

learnnc.org
lighthousefriends.com
livescience.com

M

marineinsight.com
monitor.noaa.gov
mufon.com
myfox8.com
myreporter.com

N

nationalgeographic.com
national-paranormal-society.org
naturalplane.blogspot.com
navysite.de
nccoast.org
ncdcr.gov
ncgenweb.us
ncghostguide.byethoyt12.com
ncgypsy.com
nchistoriccities.com
nchistoricsites.org
ncparks.gov
ncpedia.org
nc-wreckdiving.com
newbernhistorical.org
northbeachsun.com
northbrunswickmagazine.com
northcarolinaghosts.com
northcarolinahauntedhouses.com
northcarolinahistory.org
northcarolinashipwrecks.blogspot.com
nps.gov

O

offbeattravel.com
onlyinyourstate.com
ourstate.com
outerbanks.com
outerbankschamber.com
outerbanksdistilling.com
outerbanksthisweek.com
outerbanksvacations.com
outerbanksvoice.com

P

paranormalenlightenment.com
phantomsandmonsters.wikifoundry.com
pilotonline.com
portcityparanormal.com
prairieghosts.com
pulloverandletmeout.com

R

realhaunts.com
roadsideamerica.com
roanokeislandinn.com

S

sanctuaries.noaa.gov
secretary.state.nc.us
seekghosts.blogspot.com
shoutaboutcarolina.wordpress.com
sites.nicholas.duke.edu
snopes.com
southernmemoriesandupdates.com
starnewsonline.com
sunsurfreality.com
supernaturalhappenings.thoughts.com

T

thegrumpyoldlimey.com
thenightshift.com
theouterbanksvoice.com
thesnaponline.com
tripadvisor.com
twiddy.com

U

uboat.net
urbanghostsmedia.com

V

villagerealityobx.com
visitcurrituck.com
visitnc.com

W

wbrc.com
wcti12.com
welcometonc.com
whaleheadwedding.com
what-when-how.com
witn.com
worldufophotos.org
worldufophotosandnews.org
worldwar2database.com
wral.com

About the Author

S herman Carmichael, a native of Hemingway, South Carolina, currently lives in Johnsonville, South Carolina. Carmichael has spent the last forty-five years dabbling in things that are best left alone, like ghosts, UFOs, monsters and other strange and unusual things. He has seen, heard and been touched by things that defy explanation. Carmichael's first three books—*Forgotten Tales of South Carolina*, *Legends and Lore of South Carolina* and *Eerie South Carolina*—center on ghosts and the strange and unusual. In his fourth book, *UFOs over South Carolina*, Carmichael takes a closer look at hovering objects and strange lights in the sky. His latest book, *Strange South Carolina*, returns to the ghostly encounters. Carmichael has traveled throughout the United States visiting haunted locations. He has also traveled to Mexico and Central America researching Mayan ruins. He plans to continue visiting these unusual places for many years to come. Carmichael worked as a journalist for many years, thirty years as a photographer and twenty-nine years in law enforcement.

Visit us at
www.historypress.net